IMAGES
of America

BONNEY LAKE'S PLATEAU

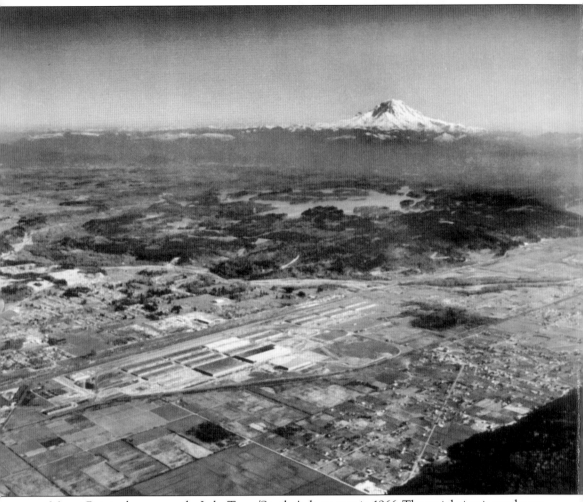

Mount Rainier looms over the Lake Tapps/South Auburn area in 1966. The aerial view is northwest to southeast, taken from about the I-5 and Highway 18 intersection. Lake Tapps is the large body of water at the center, and the White and Stuck Rivers can be seen below the tree-covered plateau. (Tacoma Public Library, Richards Studio no. D147400-24.)

IMAGES
of America

BONNEY LAKE'S PLATEAU

Winona Jacobsen
Greater Bonney Lake Historical Society

ARCADIA
PUBLISHING

Published by Arcadia Publishing
Charleston, South Carolina

Printed in the United States of America

Library of Congress Control Number: 2010935474

For all general information, please contact Arcadia Publishing:
Telephone 843-853-2070
Fax 843-853-0044
E-mail sales@arcadiapublishing.com
For customer service and orders:
Toll-Free 1-888-313-2665

Visit us on the Internet at www.arcadiapublishing.com

To my husband, Fred Jacobsen, for his unending support, constant encouragement, and enduring belief that I can accomplish almost anything.

CONTENTS

Acknowledgments 6

Introduction 7

1. The Early Plateau 9

2. The Kelley Legacy 17

3. Other Early Settlers 27

4. The Lake Tapps Reservoir 45

5. Schools and Church 55

6. Clubs and Organizations 67

7. Plateau Migration 81

8. A Town Is Created 95

9. Plateau Commerce 115

ACKNOWLEDGMENTS

This book would never have been possible without the passion and dedication of Marian Betzer, my inspiration in the quest for the historic past of Bonney Lake and the plateau. In her effort to preserve the natural Fennel Creek corridor from the destruction of development, I was inspired to seek another avenue to preserve some of our endangered sites. What I found was a virtual gold mine of unheralded historic treasures. Since no city was incorporated for nearly 100 years after its first settlement, the stories of the plateau's early pioneers have been buried in the family albums and traditions of their descendants. Nearly everyone that I contacted was most gracious and supportive of this effort to educate others about our amazing plateau.

A heartfelt thanks goes out to the following people for sharing their photographs and stories of an earlier time on the plateau: archaeologist Gerald Hedlund for his patience with me and his willingness to share his papers and insight on the plateau; Al Catanzaro for his eagerness to help map all things historic; Dennis Moriarty and his invaluable knowledge of the area history; Marian Svinth, Loretta Vasquez, and Pat Tea, descendants of William Kelley, Joan Ranch, and Louann Keough, for sharing their knowledge of their Vandermark family; and the Swiss Sportsmen's Club members, Lou Ulrich, Larry Holdener, Betty Baur, and Dick Inderbitzen, who generously opened up their own treasure trove of photographs. A special thanks also goes out to Betty Mayfield, Beverly and David Bowen, Don Frazier, Dennis Dhaese, Sue Hahto, Jim Greiner, Chris Lunn, Doug McCoy, Connie Swarthout, Marilyn Broxson, Janis Mower, Dave Berg, Quentin Clark and the Dieringer School District, Saima Hyppa, Elvin Seeley, Hulan Fleming, Barbara Clark, Joe Albert, Lawton Case, Elaine Farrar, Jill Cartwright, Inez Coyne, Glen Hamilton, Carol Ferguson, Ken Love, and David Wakefield. The majority of these photographs have not been published before, and some are not of optimal quality, but they are important to the history of Bonney Lake and the plateau. So much more is yet to be revealed, and with the continued preservation of our area's cultural and environmental resources, our community identity becomes more defined.

INTRODUCTION

The plateau on which Bonney Lake lies was once composed of multiple identifying community names like Dieringer, Elhi Hill, Connell's Prairie, Kelley Lake, Marion, and Rhode's Lake. With the exception of Buckley, nestled against the foothills of the Cascades at the east end of the plateau, no town was formed until the incorporation of Bonney Lake in 1949. That was nearly 100 years after the first settlers filed their Donation Land Claims in the newly designated Washington Territory.

In 1853, Michael Connell and James Williamson filed adjacent claims in what we still call Connell's Prairie. That was soon followed by Reuben Ashford Finnell, who filed his claim along the creek that was later named Fennel Creek. The three young pioneers each built small cabins and barns and proceeded to plant crops and improve their holdings. These farms were located along the Naches Trail, the road that ran between Fort Steilacoom and Fort Walla Walla. Only a slight improvement on the narrow Indian path that ran from Puget Sound east across the Cascade Mountains, it was the trail followed by the first wagon train that chose to veer off the Oregon Trail looking for a shorter route to the Puget Sound country. The Naches Trail carried notable northwest pioneer families like Longmire, Kincaid, Wright, Woolery, and Biles. They became founders of towns and contributed greatly to the new territory.

When territorial governor Isaac Stevens began negotiating treaties with the various Indian tribes, the first was at Medicine Creek, located between Fort Steilacoom and Olympia. The Indians were not pleased to find that they were to be moved to small, designated reservations, and over the next several months, they became increasingly agitated. On October 27, 1855, Michael Connell and Lt. James McAllister, a member of the Puget Sound Mounted Volunteers, were shot and killed near Connell's home. The following day, the Indians had crossed the White River and killed another nine people. Then on October 30 or 31, Col. A. Benton Moses and Joseph Miles were attacked and killed as their detachment of volunteers was travelling through Connell's Prairie heading west through the swampy terrain. This was the beginning of the Puget Sound Indian War, which less than a year later ended in the same area.

Settlement was slow to resume in the wilderness of the plateau following the Indian war. In 1864, the Kelley family arrived by wagon from Illinois. Nathan Kelley, his wife, and most of his children, including his son William Barton Kelley, settled on the abandoned claim of Reuben Finnell. William Kelley developed his farm, raised a family, and became a highly respected member of the community. He was elected to the territorial legislature and also served as Pierce County auditor before Washington became a state. This pillar of the plateau was so well respected by his peers that attempts were often made to draft him as a candidate for elective office in his later years. Along the old Naches Trail, just east of where it crossed the Isaac Lemon Donation Land Claim, the first oil well in western Washington Territory was drilled in 1885. The town of Elhi was platted by the Tacoma Oil Company but never developed, probably because no oil strike occurred. In the 1960s, another attempt to find oil was made on top of the plateau near East

Town of Bonney Lake, but again no bonanza was struck. Although growth continued over the years, the steep and treacherous road from the valley was a deterrent to frequent travel. In fact, it was not uncommon for some property owners to leave their farms on the plateau to spend their winters in Sumner, Puyallup, or even Tacoma. Vandermark, Moriarty, Ramsay, and Stilley were just a few of the families who settled before the 1900s.

The discussion of creating a reservoir from which to generate hydroelectric power had been bandied about for a couple of decades before work actually began. The increasing need for power permanently altered the landscape of the plateau when work began in 1909 on the Lake Tapps reservoir. Known as the White River Project, it was built by the Pacific Coast Power Company.

The Great Depression of the 1930s marked a new spurt of growth to the plateau. With the crash of the stock market and the untimely drought that created the dustbowl in the Midwest, many families chose to move west to find employment and a new place to call home. Cheap land was still available for those who were willing to drive the narrow, winding road that ascended the plateau from Sumner. The Bowens, Bushnells, Thiemans, and many other families would settle and have a lasting impact on their community.

When Ken and Bertha Simmons crossed the valley from their home in Milton and visited the plateau in 1946, they found forests and lakes and saw the potential for a recreational paradise. With the savvy of a developer and his knowledge of politics, Simmons purchased 160 acres around the little lake called Bonney. With a lot of hard work and a belief in the future, he built a resort on Bonney Lake with a clubhouse, swimming area, diving board, picnic tables, and a concession stand that sold food and beverages. Simmons subdivided his property and sold lots, but growth was hampered. A reliable water system was needed. Many residents in the area had their own wells, but they would often dry up during the hot summer months. When that happened, people would commonly meet to fill containers full of water where the natural springs ran into Fennel Creek. To finance a community-wide water system, Simmons realized the people on the plateau would have to incorporate as a town. A population of 300 was needed, and the figures miraculously reached just over that mark. On February 28, 1949, the Town of Bonney Lake was created, with Ken Simmons elected as the first mayor. Within a year, the town not only celebrated a new water system, it also had an expanded road network as well as electricity and telephone lines. The plateau was entering a new phase of growth and development.

With a history as rich as that of Bonney Lake, it is surprising to many that it took nearly 100 years after the first settlers homesteaded the plateau to incorporate as a town. Transportation was the greatest problem. With neighboring towns of Sumner and Buckley having the benefit of a railroad, Elhi Hill, as the west end of the plateau was called, suffered from a lack of adequate access. During the 1890s, it was expected that a rail line would go from the Stuck Valley up to Lake Tapps and connect to Buckley, but it never happened. The wagon road that ascended the hill from Sumner was notorious for its dangerous curves and steep incline, which discouraged many from settling on the plateau. Finally in 1920, the first concrete road was built by Henry Kaiser's paving company. Upgrades of the road have continued over the years, but transportation remains a huge issue for residents of the plateau. With increased development comes increased traffic, yet the same basic routes of a century ago continue to be used rather than new avenues of access being constructed.

One

THE EARLY PLATEAU

When much of the earth was still covered with ice, the formation of the Bonney Lake Plateau was occurring. As the ice would advance and then recede, massive boulders left behind were known as glacial erratics. A few of these glacial erratics have been found on the plateau, most notably the Sky Stone. It may not have been the largest, but its unusual shape provided the local culture a perfect surface for their mysterious carvings. These Native Americans had crisscrossed the plateau for centuries, traveling between Puget Sound and the Yakima territory east of Mount Tahoma, now known as Mount Rainier. The first recorded history of this crossing came in 1841 from Lt. Robert Johnson of the US Exploring Expedition. Later, in 1853, author Theodore Winthrop also made the trek and wrote about it in his book *Canoe and Saddle*. The route became known as the Naches Trail, and by 1853, when Congress established Washington Territory, it was improved barely enough to allow the first wagon train to cross the Cascades. Settlers began arriving who wanted to homestead up to 160 acres per person using the Donation Land Claim Act approved by Congress. The first claimants on the plateau were Michael Connell, James Williamson, and Reuben Ashford Finnell.

With the formation of the Washington Territory came the appointment of Isaac Stevens as governor. His mission was to promote treaties among the native tribes to establish reservations on which they would live, thus allowing the immigrants to homestead the vacated territory. By October 1855, hostilities broke out, and the first deaths in the Puget Sound country were at Connell's Prairie. Chief Leschi of the Nisqually tribe was tried for the death of Col. A. Benton Moses at Connell's Prairie, and a controversial verdict of guilty was rendered, resulting in Leschi's hanging. A decisive battle that ended the fighting in Western Washington was fought at Connell's Prairie several months later.

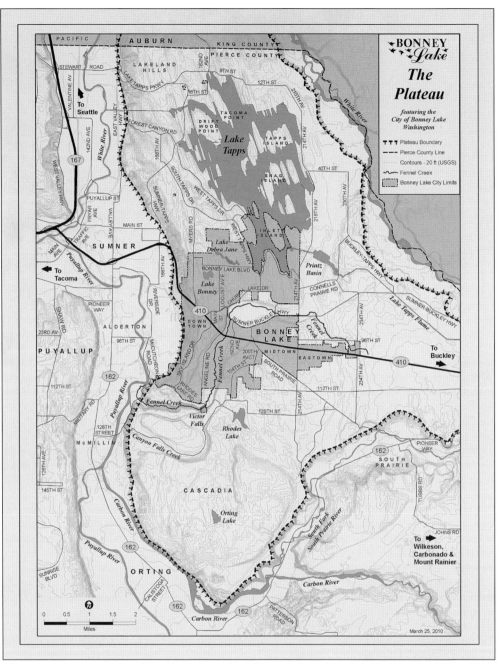

This map delineates most of the plateau on which Bonney Lake lies. Bounded by the White River to the north and east and the Auburn and Orting Valleys to the west and south, the plateau ascends to a height of more than 600 feet above sea level. The Osceola Mudflow of nearly 5,000 years ago gushed as a lahar from Mount Rainier and surged through the White River, through streams and basins, and plunged off the plateau at Victor Falls. It was also across this plateau on the Naches Trail that the first wagon train traveled, including the Longmire, Biles, and Kincaid families, and where in 1855 the Puget Sound Indian War began and then ended less than a year later. (Al Catanzaro, geographic information systems [GIS] analyst.)

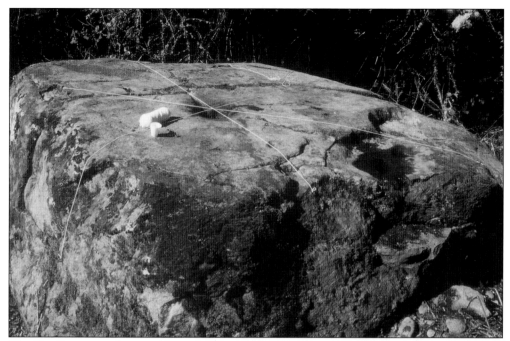

The Sky Stone was deposited by a glacier, perhaps as much as 13,000 years ago, but the human modifications to the rock occurred much more recently. The rock appears to have been shaped by Native Americans, who carved steps into the vertical side and drilled at least 20 holes of varied size in the surface of the top as well as other holes in the sides of the stone. (Gerald C. Hedlund.)

The strongest explanation of use given for the Sky Stone by archaeologist Gerald C. Hedlund and astronomer Dennis Regan has been as a prehistoric astronomical observatory and seasonal calculator. This computer-generated picture shows the significant alignments on the surface of the Sky Stone. It is likely to have provided a map of the constellations, determined direction, or indicated seasonal changes. (Gerald C. Hedlund.)

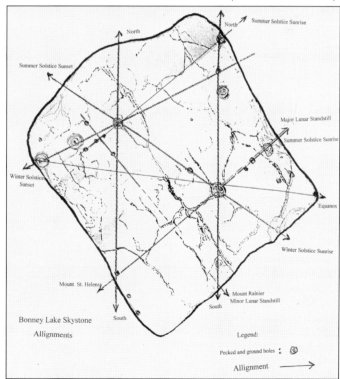

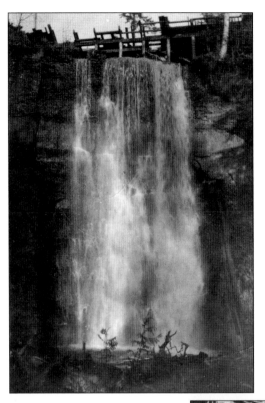

Fennel Creek tumbles off the plateau in this 1915 photograph of Victor Falls before it makes its entrance to the Puyallup River. A sawmill and bunkhouse was once located at the top of the falls. The cataract was named for Victor Johns, the youngest son of Emanuel and Mary Johns, who died at the early age of 15 in 1901. (Dennis Moriarty.)

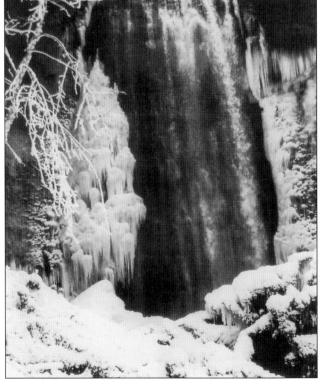

Hard winter freezes and snow are occasional occurrences in Western Washington, but this 1983 photograph shows the transformation of Victor Falls into a beautiful ice sculpture. The rarity of a waterfall of this magnitude located so close to the urban areas of Puget Sound and its general inaccessibility have kept Victor Falls one of the plateau's hidden treasures. (Don Frazier.)

Fennel Creek was named for Reuben Ashford Finnell, who settled on its banks in 1853. He built a cabin and barn and started growing crops on the prairie. His nearest neighbors were Michael Connell and James Williamson. Reuben failed to prove his Donation Land Claim when he was summoned back to Virginia in 1856. In 1864, the land was purchased by the Kelley family. (Marian Betzer, no. 269-6996.)

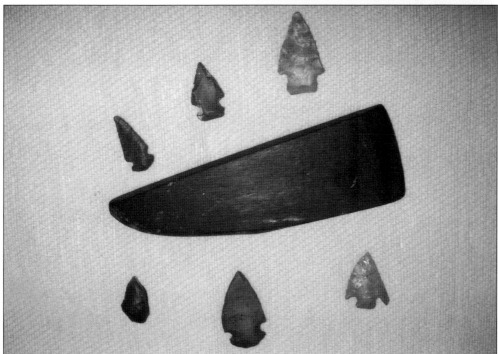

In 1918, Charles H. Moriarty was plowing the hop field where Target now stands on 192nd Avenue and State Route 410 with a horse-drawn plow. He caught the sun glinting off something in one of the furrowed rows. Upon checking, he uncovered a number of projectile points and an axe head, which still bears the scar from the scraping of the plow. This was an area that had previously been used by Native Americans for tribal gatherings. (Moriarty family.)

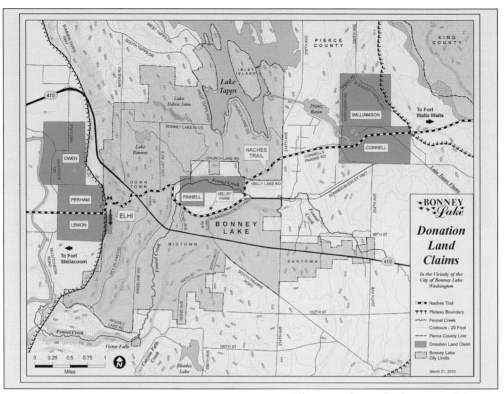

This map shows the location of the Donation Land Claims that were filed by settlers of the plateau and in the valley along the Puyallup River. These farms were all located along the Naches Trail, the pioneer equivalent of a modern east-west highway across the mountains. Homesteaders would usually select a prairie that was near a source of good water to stake their claims. (Al Catanzaro, GIS analyst.)

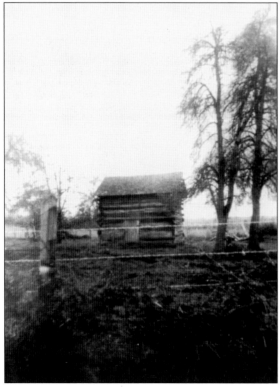

This cabin, thought to have been a Hudson Bay Company trapper's cabin, was originally located on the Jeremiah Stilley farm. It was purchased in 1955 by Federal Old Line Insurance Company in Federal Way and moved to an area behind the shopping center, which was to be called Heritage Park. In 1991, the Foothills Historical Society acquired the deteriorating building, dismantled and tagged it, and placed it in storage in Buckley. (Historical Society of Federal Way.)

Leschi of the Nisqually Indians spent several years assisting British and later American homesteaders in the Puget Sound country. As the designated spokesman for the tribe, Leschi protested the Medicine Creek Treaty terms confining his people to a small and valueless reservation. Leschi was hanged for his alleged participation in the death of Lt. A.B. Moses at Connell's Prairie, but he was exonerated in 2004 by a Historical Court of Inquiry following a trial in absentia. (University of Washington [UW] Special Collections, NA1536.)

This historic marker at Connell's Prairie was erected in 1924 by the Washington State Historical Society. One side of the monument states, "Near here Indians lay in ambush and killed Lieutenant McAllister and Michael Connell October 27, 1855." A few days later, Col. A. Benton Moses and Joseph Miles were also killed at Connell's Prairie. These incidents marked the beginning of the Puget Sound Indian War of 1855–1856. (Winona Jacobsen.)

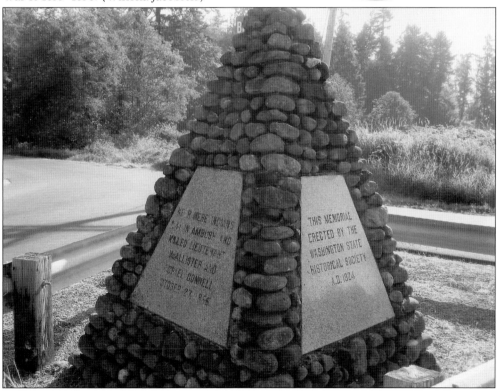

Fennel Creek had many tributaries feeding into it, including Kelley Creek, seen in this 1960s photograph. It was the former site of the Perfield hop farm, William Kelley's farm, and Rueben Finnell's Donation Land Claim. The Naches Trail, later known as the Military Road, crossed this little valley and was witness to battles during the Indian war. (Greater Bonney Lake Historical Society.)

Fennel Creek courses through the heart of Bonney Lake and was once a source of bull trout above Victor Falls. Below the falls to the creek's confluence with the Puyallup River, all four species of salmon were plentiful. This 1956 photograph captures Harold Greiner proudly displaying a trout from a fishing excursion in Fennel Creek. (Jim Greiner.)

Two

THE KELLEY LEGACY

It was several years following the conclusion of the Puget Sound Indian War in 1856 before people once again ventured onto the plateau between the Puyallup Valley and the Cascade foothills to carve their homesteads out of the wilderness. Among the first were William Barton Kelley, his bride, Mary Williams, his parents, Nathan and Elizabeth, and most of his siblings. They arrived in November 1864 after seven months of travel by ox-drawn wagon from Illinois. Their first winter was spent in the Puyallup Valley on the John Van Ogle farm, where young Mary Kelley, William's sister, met and later married the elder Van Ogle. Nathan Kelley and his son William became involved in the territorial politics of the time, and each served as a representative in the legislature. William later was elected to three terms as the Pierce County auditor, dividing his time between a house in Tacoma and his farm on the plateau at Kelley Lake.

From 1864 until its sale in 2001, most of William Kelley's farm remained in the ownership of Kelley descendants. The farm was on the Naches Trail, later known as the Military Road, which the Old Sumner Buckley Highway roughly follows today. Their source of potable water was Fennel Creek, fed by many springs with subterranean roots in the Cascade Mountains. Kelley's influence was felt from what is now Bonney Lake to Sumner, Tacoma, and the territorial capital. His friends and acquaintances included mayors, governors, presidential candidates, and the well-known patriarch of the valley, Ezra Meeker. William Kelley had a long and varied career as farmer, miner, legislator, schoolteacher, and logger. His love of nature and the outdoors was passed down to his children. Newspaper articles of the 1890s describe him as a venerable sage, widely respected by all who knew him.

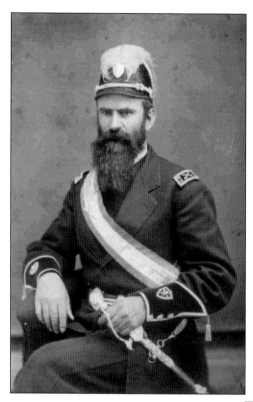

During 1864, William Barton Kelley and his young wife, Mary Williams Kelley, travelled by wagon train from their home in Illinois to the banks of Fennel Creek. William's father and mother, Nathan and Elizabeth Kelley, along with most of his many siblings, left Illinois in April with six wagons and arrived in Washington Territory seven months later. The Kelleys acquired the former Finnell Donation Land Claim by preemption and purchased additional acreage. William completed a cabin for his family in the spring of 1865. By the spring of 1866, with supplies and money exhausted, Kelley moved to Thurston County, where he found temporary work teaching school in the summer and working in a logging camp in the winter before returning to his homestead in 1867. (Both, Kelley family.)

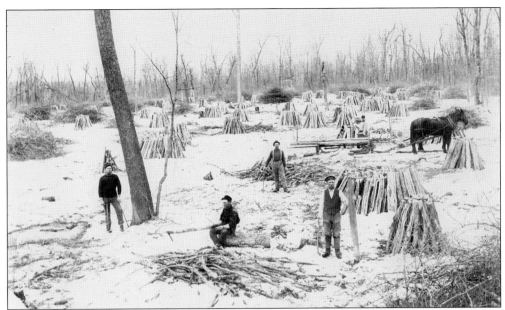

Preparing wilderness land for farming was hard work that would continue through the winter months. This undated photograph of Kelley family members may have been taken around 1900. Van and Frank were preparing to leave for the gold fields of Alaska, leaving the farm in the care of their brother John, who would stay to assist their aging father, William. (Kelley family.)

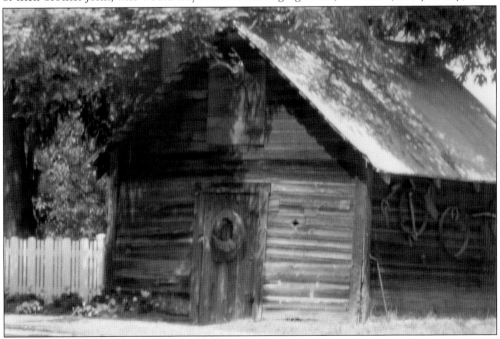

The oldest existing building on the Kelley farm, and possibly in Bonney Lake, is the former icehouse, built some time in the 1880s. Living in Tacoma during his days as Pierce County auditor, William Kelley probably wanted to enjoy some of the luxuries of city living. Built by William and his sons, the building has been used for many other things since the days before electricity. (Winona Jacobsen.)

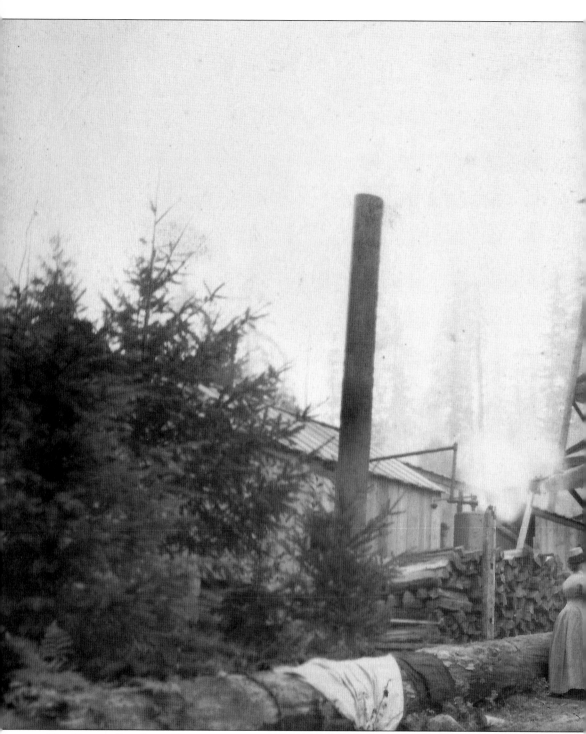

The Tacoma Petroleum Company was incorporated in April 1885 for the purpose of drilling for oil at Elhi, located along the old Naches Trail, later known as the Military Road. Located above the valley yet below the top of the plateau, this was the first oil well in western Washington Territory and was located on land purported to belong to William Kelley, one of the founders and

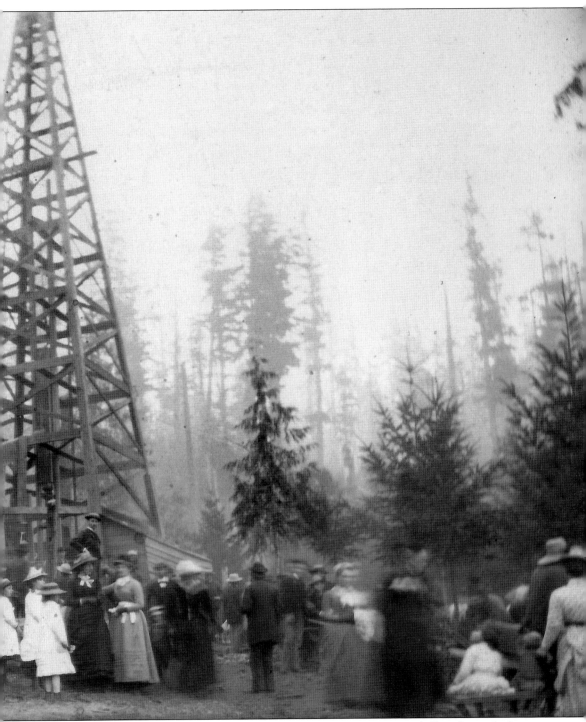

shareholders in Tacoma Petroleum. On August 22, 1885, at 1:30 p.m., drilling began before a festive crowd of about 150 people who turned out to hear speeches given by Gov. Watson Squire and Tacoma mayor Jacob Weisbach. After drilling more than 1,500 feet, the site was abandoned when no oil was struck. (Marian Svinth.)

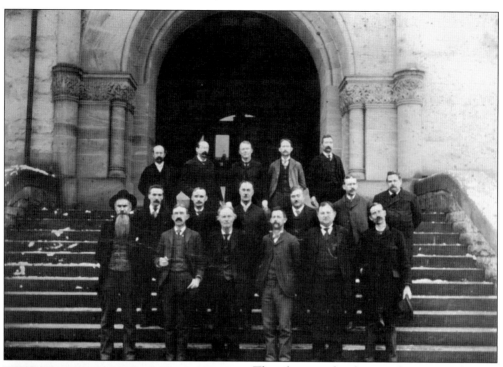

This photograph taken on the steps of the Pierce County Courthouse in Tacoma appears to have been made during the brief visit to Tacoma of William Jennings Bryan, former presidential candidate, on April 3, 1900. Bryan, reported in the local newspaper as looking tired and unhealthy with dark circles under his eyes, may be the third from the left in the first row. The bearded gentleman on the far left of the first row is William B. Kelley. (Kelley family.)

William B. Kelley's accomplishments were many. He was one of the original members of the Tacoma Board of Trade, which became known as the Tacoma Chamber of Commerce, and a signatory on the indenture of the Fannie C. Paddock Memorial Hospital in Tacoma in 1882, which later became the Tacoma General Hospital. Kelley was a member of the Masonic order, Afifi Temple, and the Knights of Pythias and a charter member of the Independent Order of Odd Fellows lodge at Puyallup. (Kelley family.)

John Ezra Kelley, born in 1871, was the third child of William and Mary Kelley, but he assumed the duties and responsibilities of the eldest when both his older siblings died at an early age. John was 36 years old before deciding to marry the pretty young Sadie Crider, who worked as a salesgirl at the Snyder dry goods store in Sumner. (Kelley family.)

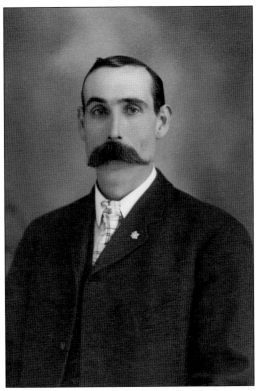

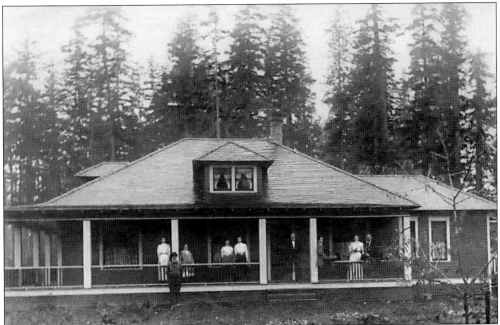

Longtime bachelor John Kelley married Sadie Crider, 14 years his junior, on November 20, 1907. Prior to the birth of their first child in 1912, a new and larger house was built on the Kelley farm. This home became the site of many social and community functions on the sparsely populated plateau. (Kelley family.)

The rush to the Klondike began with the discovery of gold at Dawson, Yukon Territory, in 1896. By 1899, the gold rush was over, but thousands recalling the gold fever of the California forty-niners continued to arrive. Only 19 years old, Van Ogle Kelley joined the throng hoping to strike it rich. Unlike the bearded veteran sourdoughs, Van and his friends display a youthful exuberance in this 1900 photograph. (Kelley family.)

The Reverend William J. Maynard was one of the founders of the Sumner Baptist Church. He was grandfather of two notable early Bonney Lake residents, Sadie Crider Kelley and Evelyn Maynard Haase, and the father of Mark Maynard, owner of the Hotel Sumner. Reverend Maynard died in March 1908 in Sumner. (Kelley family.)

Frank W. Kelley, son of William and Mary Kelley, was born in Washington Territory in 1874. In 1909, after returning from the Alaska gold fields, he married Maude Arnold. The newlyweds moved to a farm in Franklin County in eastern Washington, but by 1920, they had returned to Sumner with a family that included two young children. Frank retired from the Pacific Lumber Company as a carpenter but continued to find pleasure in his beloved mountains. (Kelley family.)

Frank Kelley was most often seen by his family dressed in a red hat with a plaid shirt, his traditional outdoorsman's garb. He held a lifelong love for the outdoors like his father before him. Frank Kelley's experience mining in the Cascade Mountains was beneficial during his quest for gold in Alaska. (Kelley family.)

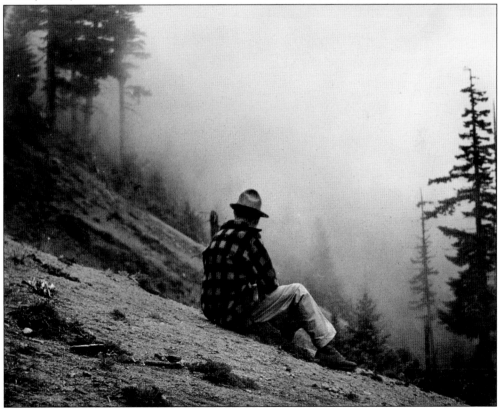

Marion Kelley was born in Minnesota in 1912 while his parents, John and Sadie, were visiting family. He attended Washington State College during the Depression, but when he had the opportunity to work for the Washington State Department of Highways, he left college with one semester to go before graduation. In November 1940, Marion had just been picked up from his job on the Tacoma Narrows Bridge by his wife, Violet, before the winds hit and "Galloping Gertie" plunged into the water. (Kelley family.)

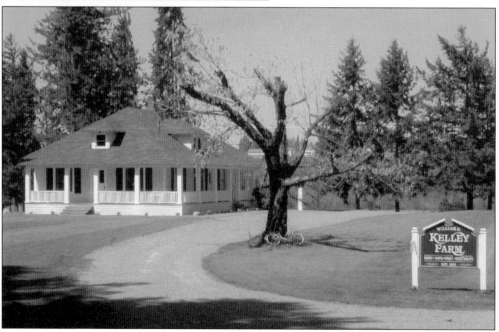

Following the purchase of the property in 2001 from the descendants of William Kelley, changes were made to the house and acreage, and plans were made public for a possible housing development. In May 2006, Kelley farm was placed on the Washington Trust for Historic Preservation's list of the top 10 most endangered historic sites in the state. (Winona Jacobsen.)

Three

OTHER EARLY SETTLERS

As time marched on, although more families came to the plateau, settlement remained sparse because of the wildness and relative inaccessibility of the area. The 1880 census listed the residents of the plateau as part of the Puyallup Valley, not recognizing any distinct plateau community. This was a period of political reform, conservation with the establishment of national parks, and world war followed by prosperity and ending in depression. The people of the plateau went from their horses and buggies to automobiles, but the infrastructure failed to keep up with these advances. The road that climbed Elhi Hill out of the valley town of Sumner was notoriously bad. Some resident families would leave their hilltop farms in the winter months for the comfort and convenience of Sumner or even Tacoma. Several families found it more convenient to frequent the town of Buckley to the east rather than risk traveling the wagon road to Sumner. Buckley's proximity to the coalfields in the foothills and an immense source of marketable timber brought a rail spur from the Northern Pacific Railroad. Those not wanting to make the demanding trek by wagon to Sumner could take the train from Buckley to the Orting Valley, Puyallup, or Tacoma.

A few of the early families included names like Moriarty, Paterson, Perfield, Ramsay, Stilley, Thieman, and Vandermark. In spite of a lack of their own town, a sense of community developed among the residents, and it was not unusual for several families to make excursions together. Trips to the beach at Redondo or camping expeditions to Mount Rainier made for great camaraderie. Families would pack their wagons and later their motor vehicles to travel in the company and safety of caravans. They enjoyed life and the natural beauty of the area, but they worked hard developing and improving family farms.

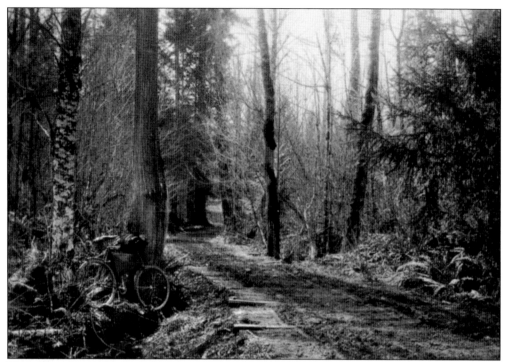

The old wagon road between Sumner and Buckley in this 1896 photograph roughly followed the old Naches Trail, later known as the Military Road. It crossed streams, wetlands, and swamps on the plateau, so portions of the road were planked to allow easier passage. Famously bad in winter, the road had few travelers, thus continuing the isolation. (UW Special Collections, WAT082.)

In 1879, James Watt Ramsay and his wife, Mary Adelaide Spaulding Ramsay, took up a homestead in the community of Marion adjacent to the Jeremiah Stilley property. They farmed at that location for the next 17 years before moving to Okanogan County in eastern Washington. Pictured are Mary Ramsay and her grandson James Ramsay in 1917. (Glen Hamilton.)

As a young man in Lozier, Iowa, Milton T. Moriarty met and married Sarah Alice Pixler on September 15, 1881. Leaving on March 21, 1883, they moved to Washington Territory. The railroad had not yet completed its connection to Puget Sound, but they still arrived in Puyallup in just 16 days. Taken around 1885, this photograph has inscribed on the back, "Dr. M.T. Moriarty, Pacific Coast Surgeon, Office at Elhi." (Dennis Moriarty.)

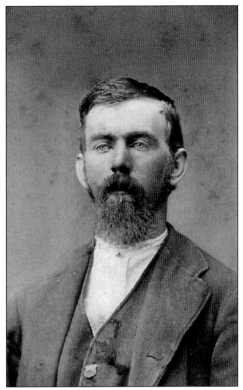

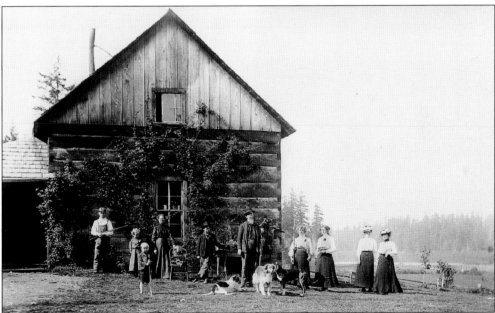

By July 12, 1883, Milton Moriarty had taken an 80-acre homestead. A month later, he bought another 40 acres from the railroad. Moriarty wasted no time in building a house. He cut the first logs on August 22 and had moved in on December 11. Milton and his family are shown at home on the shore of Kelley Lake in this 1902 photograph. The site is now part of Allan Yorke Park. (Dennis Moriarty.)

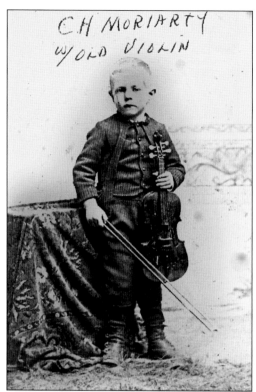

This photograph, taken about 1896, shows a young Charles Harlan Moriarty holding an old Hopf violin. The instrument had been given as a gift to his father, Milton, when he was only 12 years of age in 1870. Milton, in turn, passed it down to Charles, his eldest son. (Dennis Moriarty.)

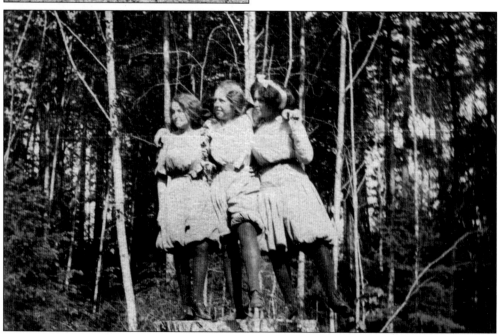

Like a trio of mythical forest sprites gamboling through the trees, these lovely young ladies pause atop a massive tree stump to admire the view and be admired in return. Posing for this early 1900 photograph are, from left to right, Pearl Hulett, Edna Moriarty, and Ada Hulett. (Dennis Moriarty.)

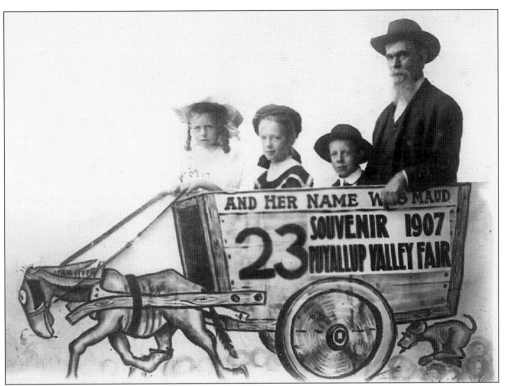

Souvenir photographs were quite popular at the 1907 Puyallup Valley Fair. Milton T. Moriarty joins his young children—from left to right, Pearl, Edna, and Louis. The sad little mule pulling the wagon perhaps signaled the impending end of horse-drawn carts, since the first automobile was brought to Puyallup in 1907. (Dennis Moriarty.)

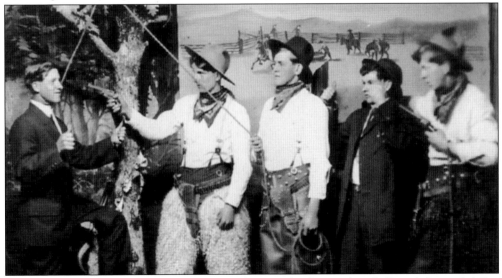

Fantasy role-playing is captured in a souvenir photograph of young friends (from left to right) Roy Hall, Johnny Erickson, George Rams, Oscar Loden, and Charles Moriarty at the 1907 Puyallup Valley Fair. They are portrayed as cowboys doling out a little frontier justice on "city dudes." (Dennis Moriarty.)

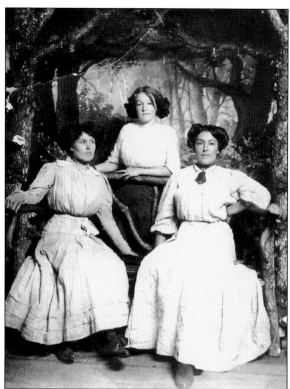

From left to right, sisters Ada, Pearl, and Bessie Hulett pose for a rare portrait. The older sisters would reminisce about their experiences as children in Nebraska following the Wounded Knee massacre of more than 200 Lakota Sioux by the US Army's 7th Cavalry just across the state line in South Dakota. When the family spotted smoke rising from a distant farm, they feared a possible Indian attack and hid for most of the day in a nearby ravine. It was later revealed that the blaze was accidently caused by the family's dog. (Dennis Moriarty.)

By 1912, the Lake Tapps reservoir had been formed when four smaller lakes had been merged, providing many boating opportunities. This photograph captures Charles Moriarty with his special young lady, Ada Hulett, on Lake Tapps. This portion of Church Lake had been popularly known as Kelley Lake. (Dennis Moriarty.)

Charles Moriarty worked in the logging industry all his life, but for a brief period, he was employed by Tacoma Power and Light at the Dieringer power plant. He was released, however, when it was discovered that he was color-blind. Although it did not hamper his ability to perform his job, he was unable to distinguish between the red and green lights on the display board. (Dennis Moriarty.)

Ada Hulett Moriarty was the second daughter of Andrew and Emma Hulett. When her mother died in 1898, Ada and her sisters, Bessie and Irene, were barely more than children themselves. They took on the responsibility of running the household and caring for their younger siblings. (Dennis Moriarty.)

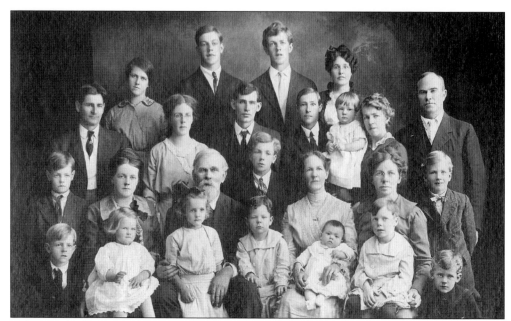

Milton and Alice Moriarty had already divorced by the time this family portrait was taken in 1915. Milton had always recorded and catalogued various aspects of his family's life, including shoe purchases and maintaining an annual weight chart for each family member. Surrounded by their children and grandchildren, the family continued to keep close ties. (Dennis Moriarty.)

Sarah Alice Pixler Moriarty and her husband, Milton, decided to end their marriage after nine children and more than 20 years together. She continued to live and farm on the plateau in what is now known as East Town of Bonney Lake. On a trip to Iowa to visit family in 1919, Alice died unexpectedly and was buried next to her parents. (Dennis Moriarty.)

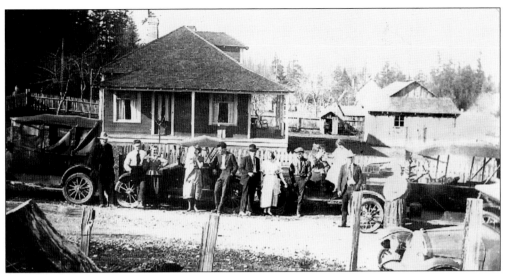

The Charles Moriarty home on Ninety-sixth Street shows a large gathering of family and friends in this 1920s photograph. Pictured from left to right are Andrew Hulett, Edd and Violet Hulett, Pearl Hood with Lucille, Stuart Hood, Fred and Irene Hornaday, Johnny Hood, Jim Moriarty, Ada Moriarty, and Joe and Lola Hulett. (Dennis Moriarty.)

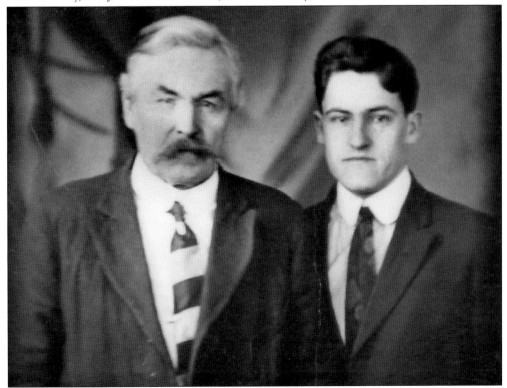

Andrew Hulett and his younger son, Edwin, probably had this photograph taken before the younger Hulett went off to fight in Europe during World War I. When Edwin returned from the war, he went to work for the Post Office Department and was a mail carrier on the plateau for a number of years until his retirement. (Dennis Moriarty.)

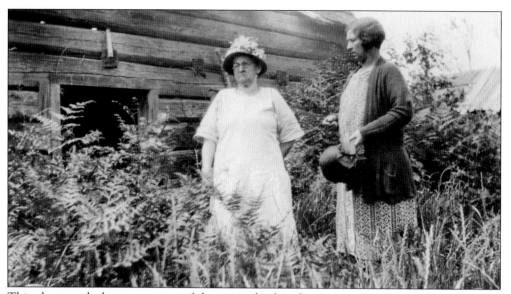

This photograph shows a portion of the original cabin that Lavina Vandermark lived in when the property was purchased by Puget Sound Power to create Lake Tapps. It was moved to the present location of the Vandermark property on 214th Avenue in Bonney Lake but was torn down around 1980. (Vandermark descendants.)

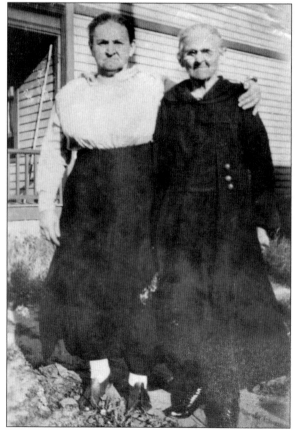

This photograph of Josephine LaRocque (left) and Lavina Vandermark, the mothers of James and Amanda, was taken at Vandermark Farm. Lavina, left a widow with the death of her husband in 1891, found her family was to be displaced by the formation of the Lake Tapps reservoir in 1910. Josephine was reportedly a descendant of Walla Walla chief Peo-Peo Mox-Mox. (Vandermark descendants.)

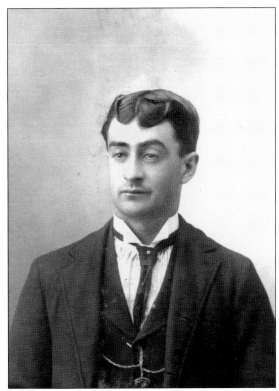

Born about 1874, James Vandermark, as shown in these two photographs, presented a rather fashionable figure around 1900. Most men were seen with an abundance of facial hair during the mid- to late 1800s, but trends began to change as the century came to a close. Clean-shaven faces replaced the beards and mutton chops, and hair was worn short and often slicked down with oils or wax. Striking a rather suave and sophisticated pose, James the gentleman farmer took over the position of head of his family before 1920. His mother, Lavina, and his older brother, Frank, continued living on the farm with him and his wife, Amanda. (Both, Vandermark descendants.)

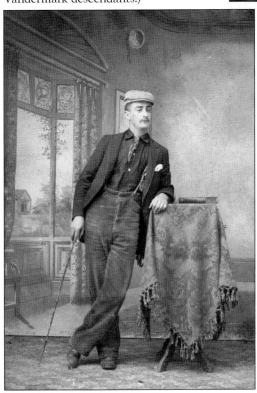

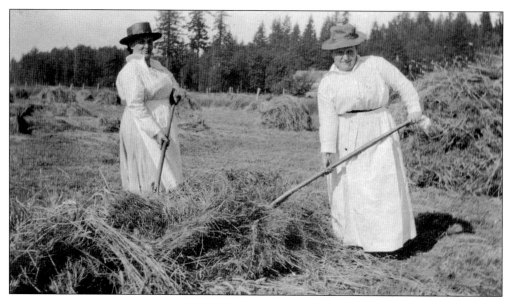

Each summer, the hay would be cut in the field and then raked into shocks or mounds, as seen here with Amanda Vandermark. Driving from one shock to the next, the hay would be loaded into the wagon using pitchforks and taken to the barn for storage. (Vandermark descendants.)

As a young man, James Vandermark began working at the Buckley Lumber Mill and later at the Paige Mill. Farming became his main occupation once he took control of the family farm. He raised vegetables, chickens, and cows and delivered his produce along a regular route. He also had a love of flowers and grew many varieties of dahlias as well as sunflowers. (Vandermark descendants.)

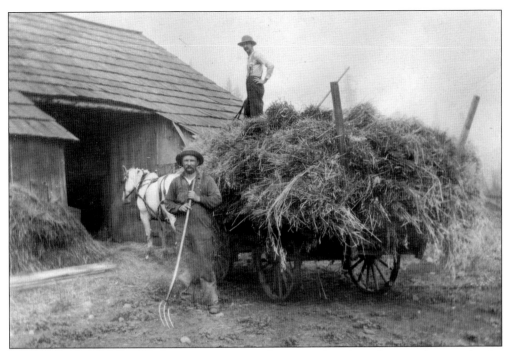

James Vandermark began his haying operation each summer by using a horse and wagon, but he did not hesitate to adopt the advances that modern technology brought. The extended families of James and Amanda were frequent summer visitors to the farm, often bringing additional "city folk" along for a visit to the country. They would come just for the farm experience, to help with the haying and the many chores, and then return to the city, happier and healthier for the exercise. The above photograph, taken about 1915, shows the hay-laden wagon returning to the barn. The below photograph was taken around 1940, again at haying time on Vandermark Farm. Helping with the process, or maybe just along for a ride on the back of the tractor, are, from left to right, Gilbert Vandermark and cousins Joan and Louann Taylor. Charles Daugherty, grandpa to the Taylor girls, stands nearby with his hat in his hand. (Both, Vandermark descendants.)

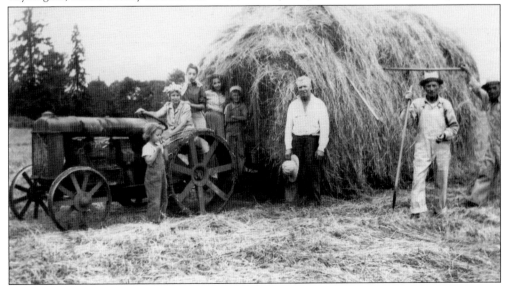

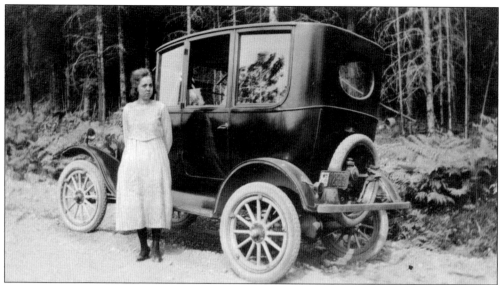

Melva Taylor, the niece of Amanda Vandermark, spent every other weekend with her family helping at the farm. During the First World War, Melva and some friends were walking along the Lake Tapps flume when armed soldiers on security patrol yelled at them to halt. Thinking the young men were just looking for attention, the girls continued walking and giggling until they heard, "Halt, or we'll shoot!" Following a reprimand, they hurried home. (Vandermark descendants.)

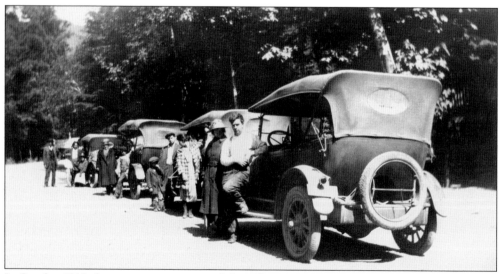

In October 1916, the newspaper announced that Elhi was "coming out of the dark," because James Vandermark had purchased a new Ford, and his friend John Kelley had bought a new Maxwell. The following August, 17 people participated in a caravan the two families formed to Mount Rainier for a week of camping and hiking. (Vandermark descendants.)

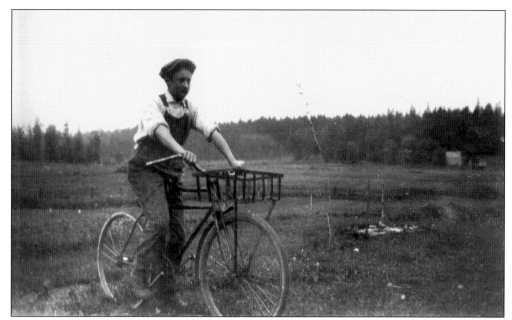

Walter Vandermark rides his bicycle at Vandermark Farm. He was one of the founding members of the Boys Potato Club during the 1920s. His thriving potato patch of a mere quarter acre yielded more than 75 bags of potatoes. By August 1933, shortly before his 25th birthday, Walter died from a wound received when he was gored by a bull. (Vandermark descendants.)

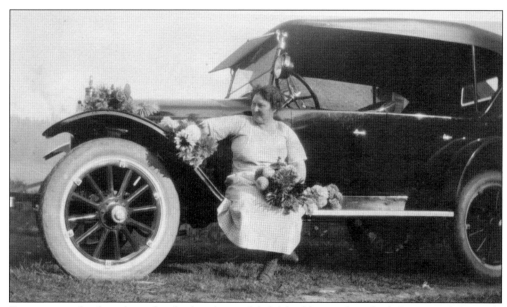

Summer on the farm brought the big, beautiful dahlia blooms for which James and Amanda Vandermark received many awards. They would sell bouquets of their prized flowers, but if a friend, or even a stranger, stopped by the farm, Amanda was likely to send the person on his way with an armful of flowers, vegetables, or a basket of eggs. (Vandermark descendants.)

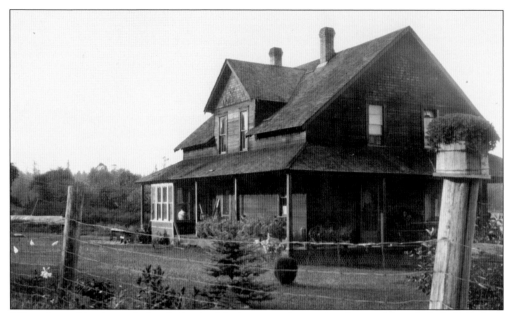

When James Vandermark decided to build a bigger and nicer farmhouse, he included all the best and most modern amenities. His wife, Amanda, had but one request. She wanted no fireplace in the parlor. James would chew tobacco, which she could accept, but he had the nasty habit of spitting into the fireplace, which she found totally unacceptable. (Vandermark descendants.)

James Gilbert Vandermark is surrounded by flowers in the garden at the farm. He was raised by his grandparents, James and Amanda Vandermark. His father, Walter Vandermark, died in August 1933, several months before Gilbert was born. Life on the farm provided him the opportunity to work with machinery that later evolved into a career as a mechanic in Alaska. (Vandermark descendants.)

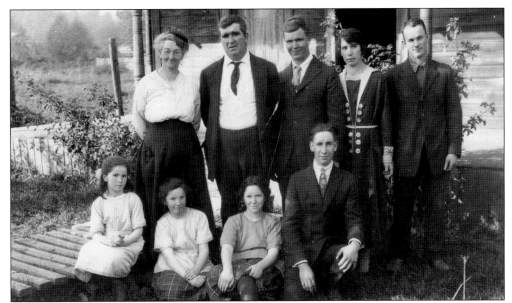

Tom and Ada Paterson moved to the plateau in 1908. Tom had worked in the coal mines of Carbonado, but not wanting his sons to go into the same kind of dangerous work, he moved his family away from the mines and decided to take up farming. In this photograph are, from left to right, (first row) Charlotte, Hazel, Ada, and Glen Paterson; (second row) Ada Paterson, Tom Paterson, Alex Paterson, Eva Peoples, and Dan Peoples. (Paterson-Peoples family.)

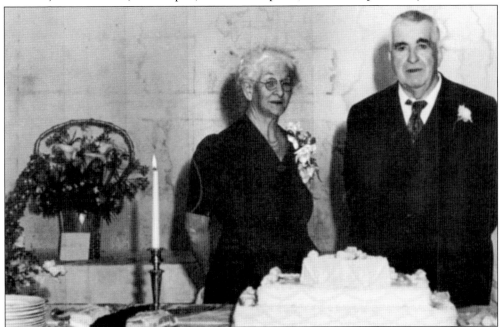

July 2, 1946, marked the 50th wedding anniversary for Tom and Ada Paterson. A large celebration with over 200 guests was held at the Marion Grange. The following evening, about 50 friends and neighbors surprised Tom and Ada with an old-fashioned shivaree. This was a surprise for the unsuspecting couple, with everyone arriving at a late hour and bringing cake, ice cream, and coffee for the festivities. (Paterson-Peoples family.)

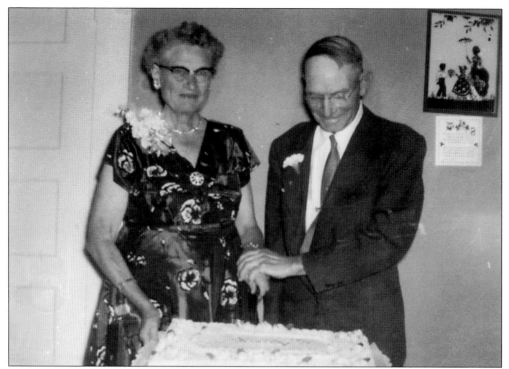

Elmer and Nellie Thieman celebrate 50 years of marriage in 1958. They moved to Washington from Nebraska in 1913, first settling in Puyallup. In 1922, they bought a 40-acre plot of land with a three-room house at Elhi that had no electricity or running water. Elmer would drive to work at the Extension Center in Puyallup in his 1919 Chevrolet touring car. (Thieman family.)

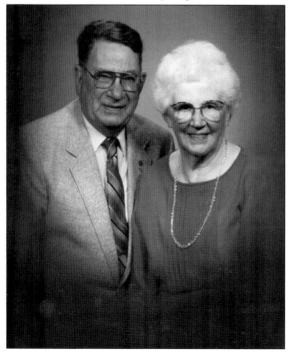

Ray Thieman and his wife, Helen, bought a 40-acre tract of land in 1933 adjacent to his parents, Elmer and Nellie. Ray built the small two-bedroom house, but the family moved into it before it was completed. Helen was active for many years as a 4-H leader and served as past master of the Marion Grange. Ray and Helen pose for a portrait on their 50th wedding anniversary in 1981. (Thieman family.)

Four

THE LAKE TAPPS RESERVOIR

Lake Tapps, as it is known today, was formed as a result of the White River Project, built by Stone & Webster for the Pacific Coast Power Company beginning in 1909. Its purpose was to create a hydroelectric power plant in Dieringer with water diverted from the White River in Buckley through a series of flumes and basins to Lake Tapps. The 14-mile-long project included 19 dams and embankments, seven miles of storage basins, and five miles of canals. Building the flumes, canal linings, and rail trestles required 20 million board feet of timber. The on-site sawmill, which was located near the outlet canal to the northwest, provided 75 percent of this. There was enough lumber to build a five-foot sidewalk stretching from Seattle to New York. Four natural lakes—Crawford, Kirtley, Church, and Tapps—were flooded to create the Lake Tapps reservoir. The resulting storage provided 2.5 billion cubic feet of water, which had the potential to generate 18 million kilowatt hours of electricity.

The work in the field was completed in only 20 months in a region that was heavily timbered and considered a wilderness. Since the Northern Pacific Railway had a station in Buckley on the east and in Dieringer on the west, a standard-gauge railway was constructed around the northern edge of the Lake Tapps basin to transport supplies and equipment to a workforce of 1,000 men in 17 camps along a 14-mile course. Embankments and levies were built to allow the completed reservoir surface to be raised by 35 feet. There was enough excavated material to fill 20,000 rail cars, making a train 170 miles in length. Through penstocks and tunnels, the water was carried to the powerhouse at the northwest end of the lake containing the largest waterwheels of their kind that had yet been built. This newly generated power was carried by the eight transmission lines to help feed the energy needs of Seattle and Tacoma, but it was more than 30 years before the residents of the future Town of Bonney Lake had electric power.

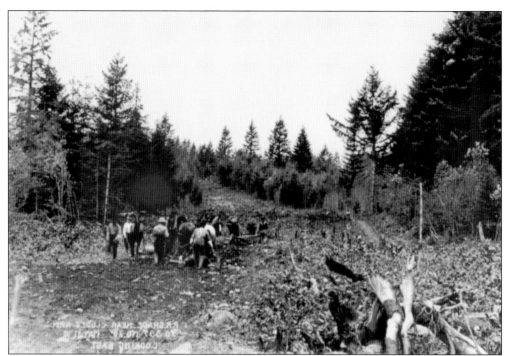

Tackling the first problem of moving supplies and work crews across the plateau, grading for the construction of a railroad is shown near Clode's Arm on the northern shore of Lake Tapps. The horse-drawn graders level and prepare a bed for a standard-gauge track in this 1910 photograph. (UW Special Collections, Puget Power 402.)

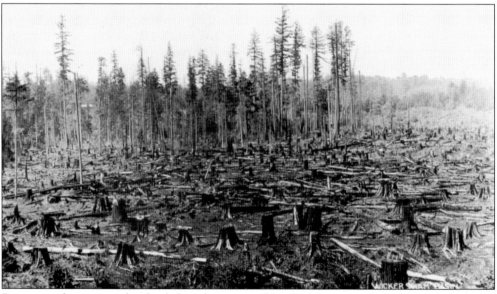

Farmers with property that lay below the proposed level of the reservoir were compensated or their houses moved to higher ground. Areas of heavy timber were logged, as in this photograph showing the clear cutting in Wickersham Basin. Tree stumps remaining in the bed of the newly formed reservoir would continue to pose a hazard to recreation in later years. (UW Special Collections, Puget Power 410.)

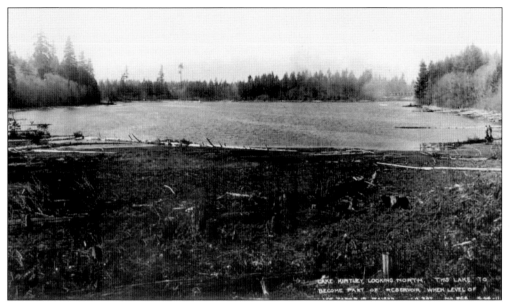

Before the flooding to create the Lake Tapps reservoir, Lake Kirtley was the scene of many family gatherings and picnics as well as annual Fourth of July celebrations. As early as 1890, area newspapers reported Lake Kirtley as a Sunday pleasure boating destination. (UW Special Collections, Puget Power 745.)

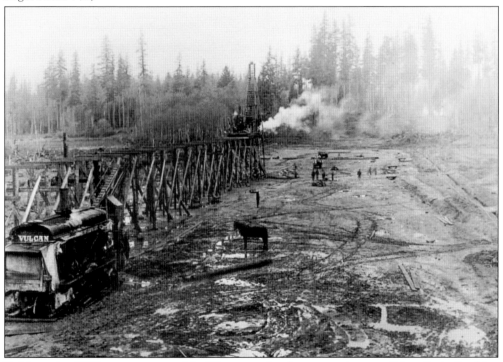

By November 1910, crews are at work building an embankment trestle across Printz Basin. Looking west, the photograph shows stacks of cut timber in the background and modern steam equipment in use in the very wet bottoms of the basin as a lone horse surveys the work. (UW Special Collections, Puget Power 500.)

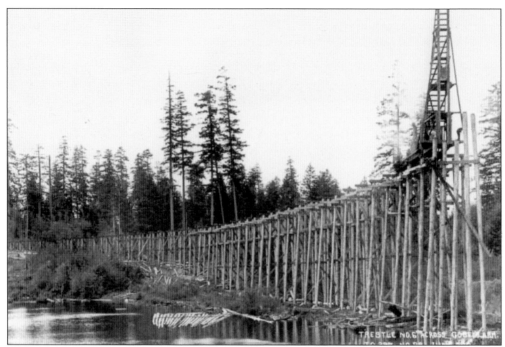

Crews work on the construction of railroad trestle Number Six across Gobel's Arm, one of the northern arms of Lake Tapps. The tracks allowed the crew to more easily and efficiently fill in the embankments to complete the reservoir. This photograph is looking to the southwest. (UW Special Collections, Puget Power 420.)

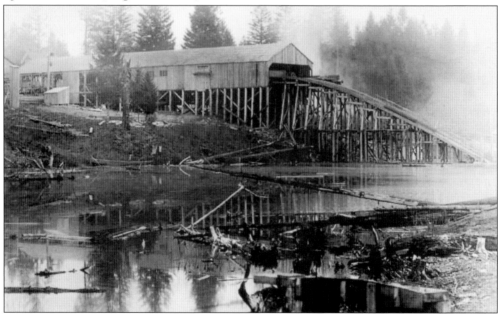

This sawmill was built along the outlet channel at the northwest end of Lake Tapps and adjacent to the railroad. It processed 75 percent of the lumber necessary in building the required flumes, canal linings, and train trestles for the White River Project. (UW, Special Collections, Puget Power 680.)

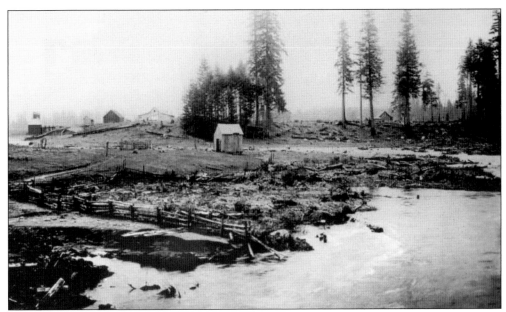

Some farmers had to be moved from the areas that were to be flooded by the rising level of the reservoir. James Printz found that his land was needed for the project's fifth water storage basin before the waters of the flume reached Lake Tapps. This photograph depicts the flow of water from the timber-lined flume through a small canal to Printz Basin. (UW Special Collections, Puget Power 1019.)

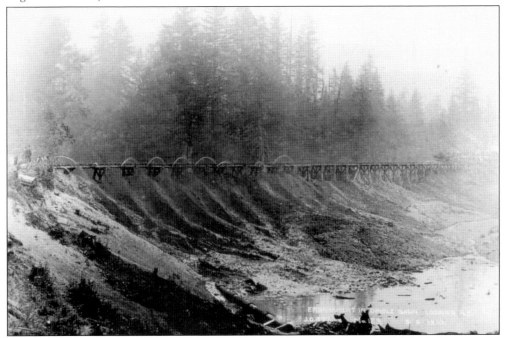

The men in the photograph are using jets of water along a trestle to move dirt and clay to create an embankment in Dingle Basin. Looking northeast in this September 1910 photograph, the scene is near the entrance to the flume at Mundy Loss Road. (UW Special Collections, Puget Power 584.)

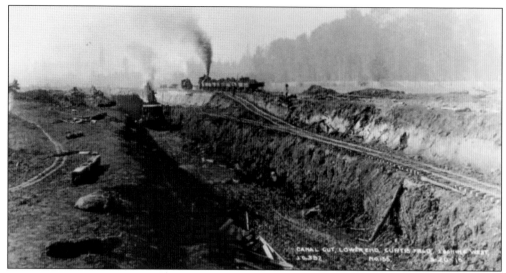

By September 26, 1910, a canal was being cut at the lower end of Curtis Field, southeast of Lake Tapps. Looking west, the railcars are loaded with some of the one million cubic yards of excavation material that was dug during the course of the project. (UW Special Collections, Puget Power 461.)

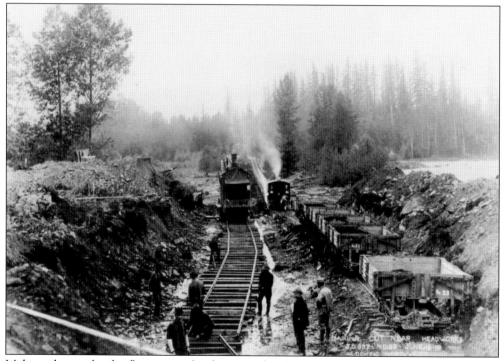

Making the cut for the flume near the diversion dam head works, men can also be seen laying rail track for the locomotives. This will enable them to carry the excavated material away to deposit elsewhere in order to create embankments. (UW Special Collections, Puget Power 446.)

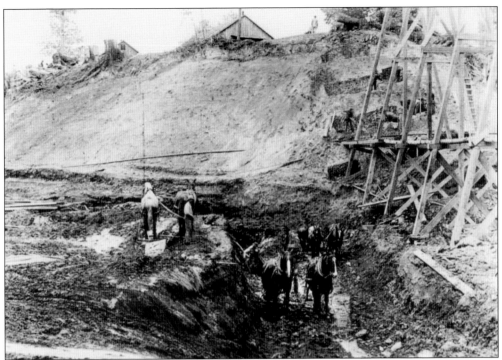

Scrapers pulled by teams of horses were used to excavate the cut in Dingle Basin near the canal. The temporary trestle for the embankment can be seen adjacent to the ditch that the horses are cutting. (UW Special Collections, Puget Power 451.)

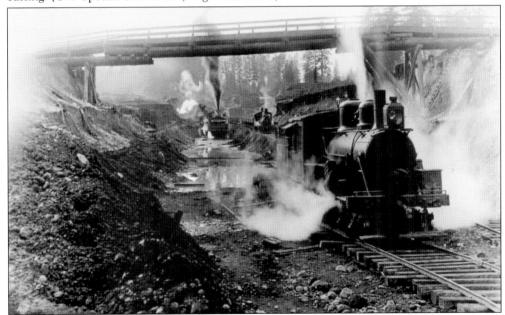

The locomotives, with steam billowing on a cold day in February 1911, follow the tracks laid in the bed of the outlet canal as it extends from Lake Tapps toward the west. Transporting supplies and equipment for the continued excavation, these trains helped make quick work of such a massive engineering feat. (UW Special Collections, Puget Power 678.)

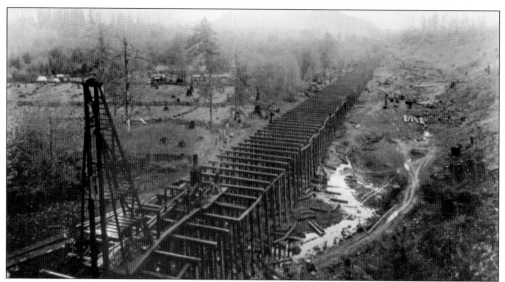

For many years before the actual construction of the White River Project, power engineers were attracted to the White River and the unique configuration of the plateau. Diverting a portion of the White River at Buckley, a series of flumes and canals was constructed to channel the water into basins and minor storage lakes. The wooden flume, as it left the White River, was eight feet deep and 28 feet wide. A gravity flow was accomplished with a slope of seven feet to the mile. The photograph above shows the trestle for the flume line near Buckley, looking east. The photograph below shows the west end of the plateau, where construction of the covered flume from the northwest corner of Lake Tapps to the tunnels and penstocks can be seen. (Both, UW Special Collections. Above, Puget Power 503; below, Puget Power 822.)

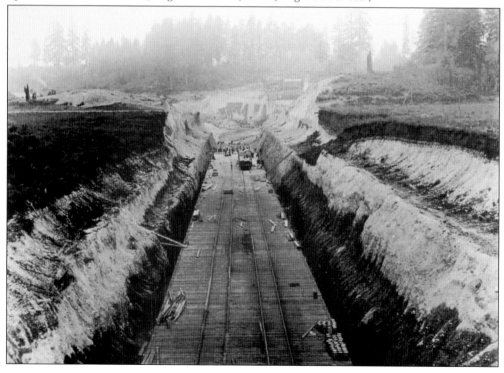

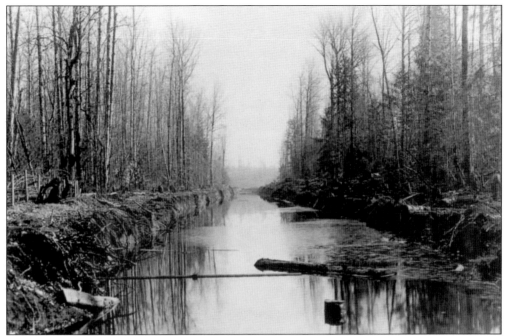

As the water flowed toward the western edge of the plateau, the natural basin with four small lakes was flooded and merged into one single large reservoir. The resulting Lake Tapps emerged with a 45-mile shoreline situated 35 feet above the level of the original smaller lakes. This photograph shows the cut for the flume between Camps Six and Seven on February 22, 1911. (UW Special Collections, Puget Power 691.)

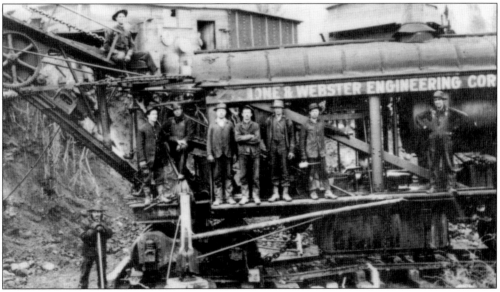

The equipment and crew of the Stone & Webster Engineering Corporation that dug the channel for the inlet and the outlet of Lake Tapps, as well as the channel near the present county park, are pictured at Camp Five at Lake Tapps. Among some of the men pictured are Mike Baydo (standing at left foreground), Tom Petersen (second from right), and a Mr. Barns (top left). (Dieringer School District.)

In June 1928, while on an outing at Lake Tapps, Ed Berg and his son Bob are pictured standing near one of the early train trestles that had been built during the formation of the reservoir. Berg served as the publisher of the *Enumclaw Herald* between 1927 and 1932. (Dave Berg.)

Jenks Park was one of several private parks that had been created by the Lake Tapps Development Company. On the hill above the park was the Clifford ranch, where developer Ben Clifford kept a summer home and raised exotic pheasants, peacocks, and a variety of raptors. (Greater Bonney Lake Historical Society.)

Five

SCHOOLS AND CHURCH

Before the close of 1889, Congress created Washington as the 42nd state of the Union. The legislature enacted specific laws regarding the funding of schools and the education of its children. Many communities came forward to request the formation of new or expanded school districts. Even remote Bonney Lake Plateau saw several one-room schools built, usually on land that was donated by a landowner or sold for a pittance. Between 1889 and 1892, the plateau had the following school districts: Dieringer, Kelley Lake, Lake Tapps, Marion, and Rhode's Lake. Eventually, all districts except Dieringer merged with either the Sumner or the White River School Districts.

Churches, on the other hand, were much slower to establish themselves. Most of the plateau residents would attend the church of their choice in Sumner or in Buckley or perhaps not attend church all. Sometimes a schoolhouse would be used so that the children of the plateau might receive spiritual instruction from a travelling minister, although these remained nondenominational gatherings. Oscar "Doc" Bowen realized the community's need for a structure dedicated to the spiritual guidance of the people when he arrived on the plateau in 1934. He began by having services in his home, but when the number of people continued to increase, he decided to use the lumber he had purchased to finish and enlarge his home to build a small chapel. Bowen contacted his former minister, Rev. W.L. Tanner of Brush, Colorado, and convinced him to come to Elhi Hill. With just eight people, a charter was signed, and on May 30, 1936, the Church of the Nazarene on Elhi Hill was officially sanctioned by superintendent E.E. Martin.

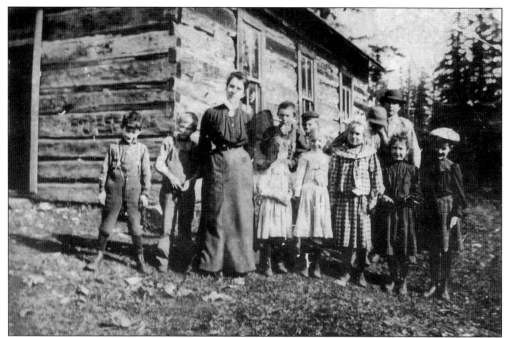

Rhodes Lake School District no. 58 was established in 1889, and the first record in January 1890 showed 14 students registered. This 1904 photograph includes members of the William Schroeder family—Elsie, Minnie, Paul, and Carl. In 1939, the district was merged with Alderton. In 1957, there was another merger with the Sumner School District. (Don Frazier.)

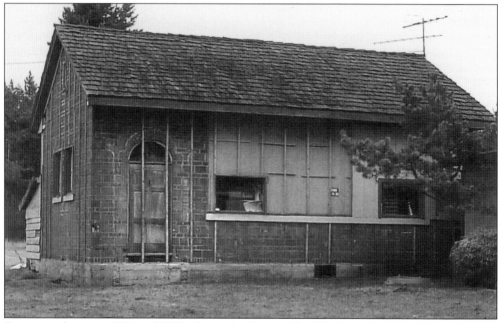

Some time between 1904 and 1918, the log building of the Rhodes Lake School burned down, and a new school of brick was erected in its place. When the school closed in 1939, the school district auctioned off the property. Chet and Christine Forcum placed the winning bid and used it as their home for the next five years. (Don Frazier.)

Students at the Lake Tapps School pose for this 1911 photograph. They are, from left to right, (first row) Walt Coby, Paul Fadola, Anna Lappenbusch, and Claudia Fick; (second row) Andrew Locke, Lulu Lappenbusch, S. Sorensen, Chris Sorensen, and Olga Fick; (third row) Mike Fick, John Sorensen, Ernest Lappenbusch, Mary Lappenbusch, and Annie Fadola. (Dieringer School District.)

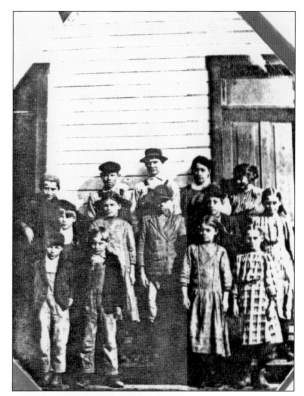

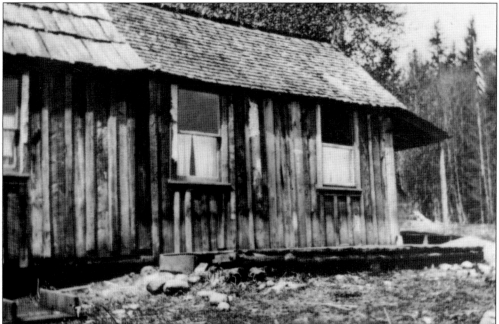

This 1918 photograph shows the temporary schoolhouse of the Lake Tapps District located on the Lee Davis property. By 1951, the abandoned Lake Tapps schoolhouse was used as a lodge for the rehabilitation of alcoholics. Pierce County prosecutor John J. O'Connell was the chief supporter and the first chairman of the project. (Dieringer School District.)

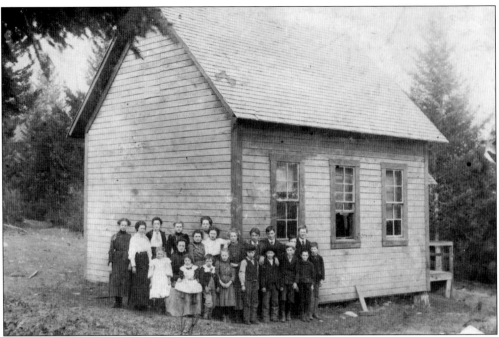

The first Kelley Lake School was built about 1889 by William Kelley and sons on the northwest corner of his property. This 1901 photograph shows, from left to right, (first row) Tom Swint, Stella Hall, Charles Moriarty, Guy Hall, Arthur Scanell, George Smith, and Roy Hall; (second row) Bessie Rigger, teacher Agnes Kirkwood holding Arlo Delong, Laura Swint, Susie Delong, Stella Moriarty, Frank Delong, Charlie Ferguson, Al Swint, and Basil Hall; (third row) Mable Moriarty, Maudie Vandermark, Hilda Willard, Berdie Matlox, and Maude Moriarty. The handsome school board director, John Kelley, would sometimes visit Kelley Lake School to observe the proceedings. It was not uncommon for the young bachelor to escort the teacher to a gathering or take her for a ride in his shiny black buggy drawn by a team of black horses. The photograph below shows an addition that had been made to the original building. (Above, Dieringer School District; below, Kelley family.)

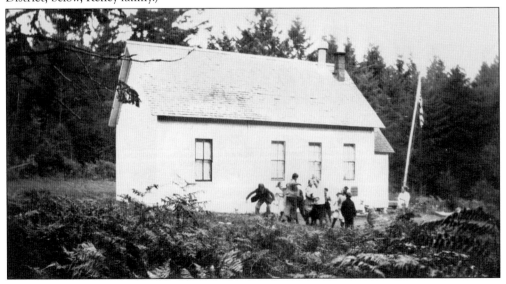

Winter TERM

Number	NAME OF PUPIL	Age	First Month from Sept. 25 to Oct. 23	Mo. Summary (Days present / Days absent / Times tardy)	Second Month from Oct. 23 to Nov. 20	Mo. Summary (Days present / Days absent / Times tardy)	Third Month from Nov. 2
1	Burbank Cynthia	13	S S S / S S S S S S S S S / XX XXXXXXXXXX XX	4 3 0	XXXX X XX XX	0 0 0	
3	Huelett Pearl	14	X XXX	14 4 0	X	9 1 0	
6	Hall Emily	13	. .	18 0 1		10 0 0	
7	Paterson Eva	12	X XX	15 3 1		10 0 0	
9	Moriarty Pearl	10		18 0 1		10 0 0	
11	Knickerbocker May	10		18 0 0		10 0 0	
13	Baer Daisy	13	S S S S S S S / X X X X X X X XX XX XX	4 3 0	X	9 1 0	
14	Hoover Josie	6	:	18 0 0		10 0 0	

(notations in Second Month columns: "School closed" and "on account of smallpox"; in Third Month: "Institute Week")

September 25, 1911, marked the beginning of the winter term for the Kelley Lake School students. The teacher was Chauncey Gray, and his record of attendance for a portion of the 20 enrolled students shows a two-week closure due to a smallpox outbreak a month later. (Peoples Paterson family.)

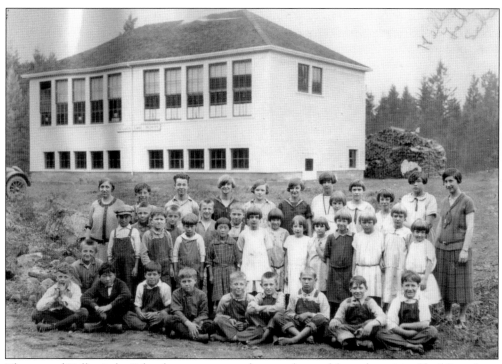

The second Kelley Lake School was constructed across the road from the original building about 1921. There were two classrooms on the top floor, and the children used a play area in the basement during inclement weather. This photograph from the 1920s shows the large amount of firewood used by the school, which paid about $5 per cord. (Bowen family.)

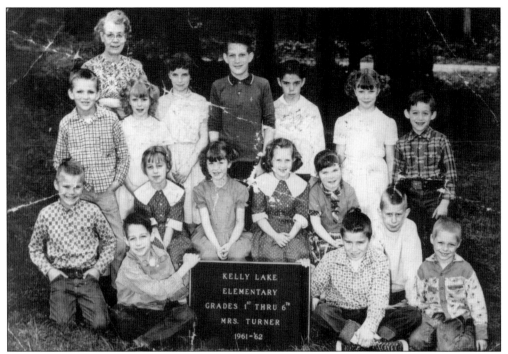

Due to dwindling enrollment, Kelley Lake School closed in 1963, and students attended either the Sumner or the White River School District. Maude Haase Turner was the last teacher of the school. Some students identified are Stew Bowen (left of sign), Julia Bowen (seated behind him), Larry Hemminger (right of sign), Joel Bowen (back row, third from left), David Zink (fourth from left), and Linda Zink (fifth from left). (Bowen family.)

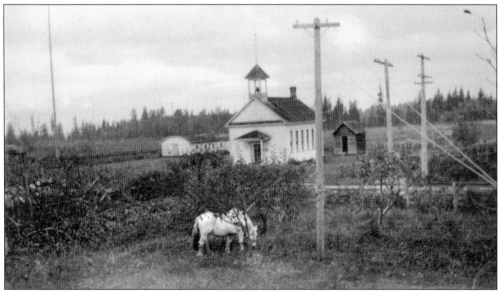

The Marion School, located on the Old Sumner–Buckley Highway, was built on a parcel of land that was purchased from Jeremiah Stilley about 1890. Stilley was the first non-Indian resident of Marion, having settled there around 1875. He served on the school board and also as Buckley postmaster before moving to eastern Washington. (Marion Grange.)

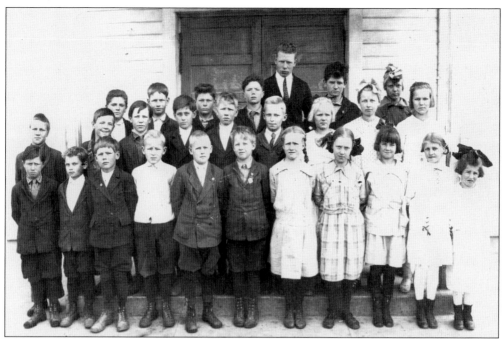

The 1917 photograph of Marion School shows teacher Pete Robertson standing in the center behind the students. Others in the photograph include (first row) John Craig (far left), Ole Mork (fifth from left), Ellen Robertson (seventh from left), Ruth Carlson (second from right), and Marguerite Albert (far right); (second row, left to right starting fourth from left) Art Carlson, Edgar Robertson, Reuben Carlson, Hilda Kulki, and Laura Mork; (third row) George Robertson (second from left) and Miles Craig (fourth from left). (Marion Grange.)

Rudolph Bakke is shown with his school bus about 1929. He had the contract to haul the school children from Lake Tapps to Sumner High School between 1926 and 1935. The school board had a strict set of rules to insure the safety and comfort of the children. The students are Nellie and Robert Thompson. (Dieringer School District.)

The Bonney Lake Elementary School was the first modern school with a unique clustered building design in Bonney Lake. It was also the first school in the Sumner School District to receive state monies on an emergency basis. Construction work had to start within one week of the acceptance of the bid. The school was ready for classes in September 1961. (Greater Bonney Lake Historical Society.)

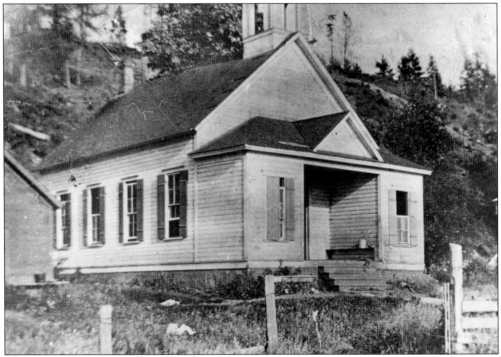

On December 6, 1890, the newly formed school district of Irvington accepted the offer of Dr. G.H. Spinning to hold classes in his warehouse until a bond could be passed and a school built. The name of the district was changed to Dieringer in 1892, and the first schoolhouse was built on the northwest side of the plateau. By 1910, the school had been removed, and the powerhouse for the Pacific Coast Power Company was built. (Dieringer School District.)

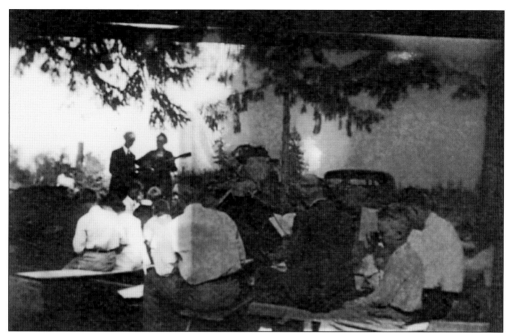

When attendance for church and Sunday school services had increased beyond the capacity of Oscar Bowen's small home, an arbor of brush and branches was erected outdoors to accommodate the growing number of worshippers. Seating was on crude benches beneath the canopy. (Bowen family.)

We the undersigned are hereby declaring ourselves a church of the Nazarene of Elhi Hill, Sumner, Wash. As charter members we do on this May 30, 1936 — organize ourselves into a local church. — It is our purpose to leave this charter open until we perfect this organization

W. L. Tanner
Mrs W. L. Tanner
Oscar Bowen
Mrs Oscar Bowen
Leora Bowen
George Bowen
~~George Morey~~
Irene Bowen
Irene

The Church of the Nazarene on Elhi Hill was officially organized by superintendent E.E. Martin on May 30, 1936. It was commemorated by the signed charter of the first pastor, Rev. Warren L. Tanner, and the original founding Bowen family members. Other early attendees were the Myers, Filkins, Bushnell, and Wedgewood families. (Bowen family.)

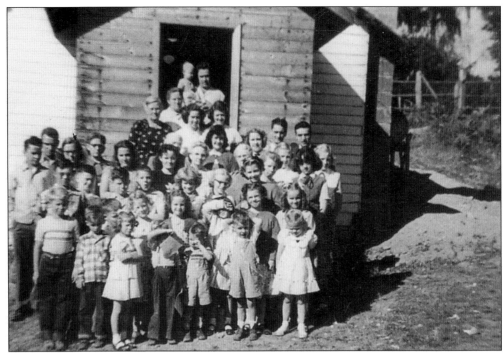

This 1940s photograph shows one of the Sunday school classes in front of the Church of the Nazarene. Oscar "Doc" Bowen would drive around Bonney Lake each Sunday morning, gathering children in his pickup truck to take them to the church. He was committed to enabling as many children as possible to hear the gospel each week. (Bowen family.)

Rev. W.L. Tanner was the first pastor of the Church of the Nazarene on Elhi Hill. Oscar Bowen had written to him in Colorado telling the reverend that his community was in need of a pastor for a new church. Tanner came to Washington, moved into a home at the top of Myers Road, and began as preacher to the flock on Elhi Hill. His wife played the guitar and provided music for many services. (Bowen family.)

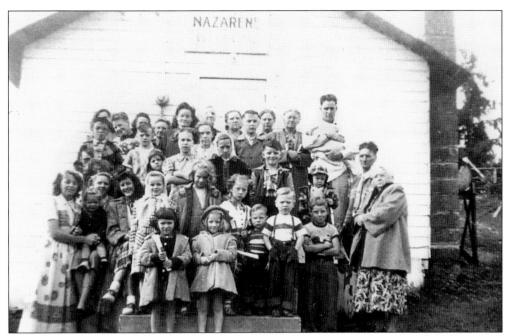

The Sunday school group at the Church of the Nazarene gathers on the steps. This photograph includes Troy Arrants, Goldia Bowen, Leora Dye, Emily Bowen, Mrs. Myers, Janey Morey, Lorraine Bowen, Beverly Bowen, and Wilma Bowen. (Bowen family.)

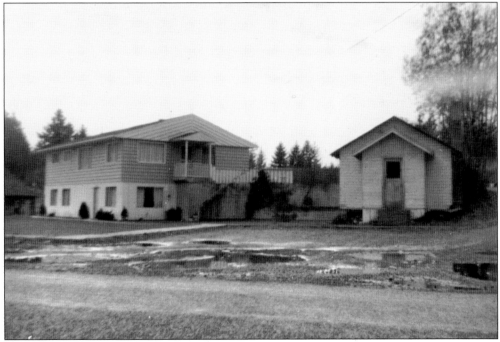

The original Church of the Nazarene was located at 7601 Myers Road. Next door the parsonage, which is now a private residence, was located on the second floor of the house, and the first floor was used as expanded church space. The original little church, the first one in the area, was torn down about 2005. (Bowen family.)

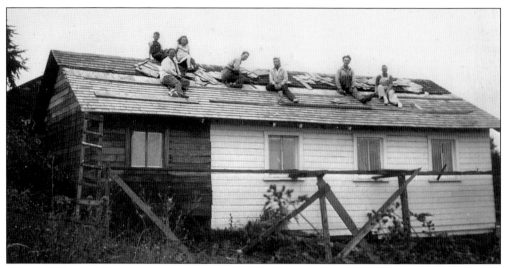

Some members of the congregation are shown putting shingles on the roof of an enlarged Church of the Nazarene. Everyone would pitch in to help, whether they were men or women, young or more mature. Pictured in no particular order are Dick Dye, Betty Mayfield, Ethel Arrants, Dickie and Leora Dye, and Irene Arrants. (Bowen family.)

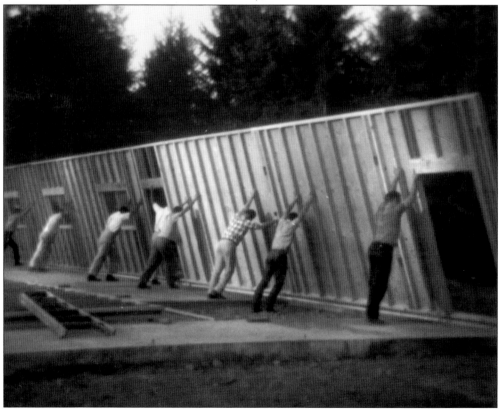

Members of the congregation came together to raise the walls of the educational unit of the Church of the Nazarene. With continued growth, the church expanded and built a new facility across Myers Road from the original little church built by Oscar Bowen. (Bowen family.)

Six

CLUBS AND
ORGANIZATIONS

Organizations have provided a sense of identity for numerous groups of people sharing like interests and concerns. The people of the plateau found they could attend a Masonic or perhaps an Odd Fellows meeting in the neighboring towns of Sumner or Buckley, but on the plateau, they formed numerous associations that became the heart of their social, political, or occupational involvements.

There were ethnic groups like the Finns and the Swiss who settled in communities and formed community halls that would allow them to practice the traditions of their forefathers. Those who were farmers formed the Grange as a way to make their political representatives aware of their needs. The Grange Hall also became the social center of the farming community. There were Boys, Girls, 4-H, and Youth Dairy clubs for the younger residents. The Garden Club, Rod and Gun Club, Improvement Club, and the Happy Homemakers Club all helped to provide support for people sharing like interests. Whether it was to learn how to graft a tree, tie a fly, or bake the perfect loaf of bread, these organizations provided a place to learn in a local environment. The ladies who might share a common interest in sewing would volunteer to donate their projects for charity, or perhaps, during the war years, create bandages in memory of the brothers, sons, or husbands who went off to battle. The members would take care of one another when times were bad and would extend a charitable hand when needed. These organizations promoted camaraderie and gave people a sense of place and identity and a means for collaboration. Yet a town was still not incorporated until 1949.

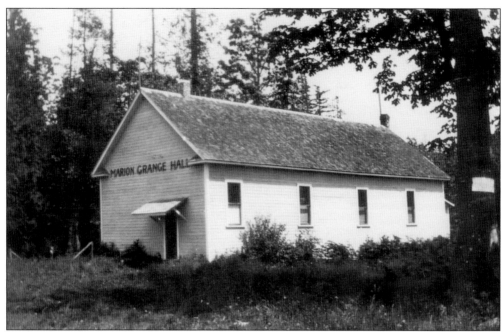

Late in 1908, the farmers of Marion and Connell's Prairie believed they should organize as part of the Order of Patrons of Husbandry. On January 5, 1909, thirty-three people gathered at the Marion School and became charter members of Marion Grange no. 276. By August, with growing membership and limited space at the school, work began to build a Grange hall. (Marion Grange.)

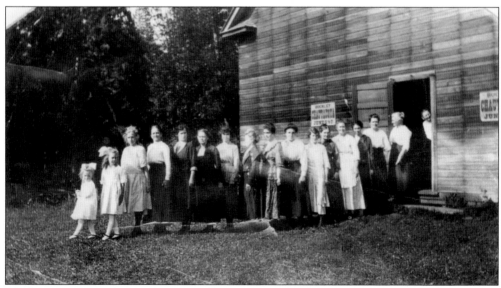

The Marion Grange frequently was used by other groups for activities, events, and performances. Electricity did not come to the hall until 1922, and water was not piped in until 1932. Pictured is a group of women and girls, and a sign on the building states, "Buckley Chautauqua June 3-7." (Marion Grange.)

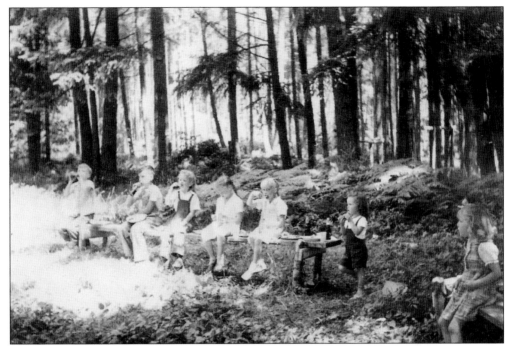

Late in the 1940s, the Victor Falls–Rhode's Lake Community Club held its summer picnic. About 50 yards south of the site of the clubhouse, these children found benches to sit on and enjoy their lunch. They are, from left to right, Don Frazier (future Bonney Lake police chief), Jack and Reka Frazier, Ardith Dale, Elva ?, Linda ?, and Janet ?. (Don Frazier.)

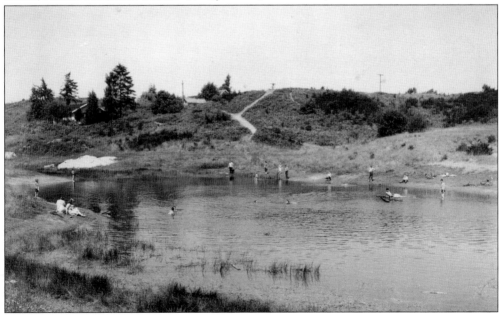

Tacoma's YMCA hosted an annual Y Summer Camp at Lake Tapps on June 29, 1948. Children of all ages would participate in one of three summer camp sessions; each session was one week long. Camp activities would be handled by counselors and would include outdoor recreation and handicraft instruction. (Tacoma Public Library, Richards Studio no. D34124-2.)

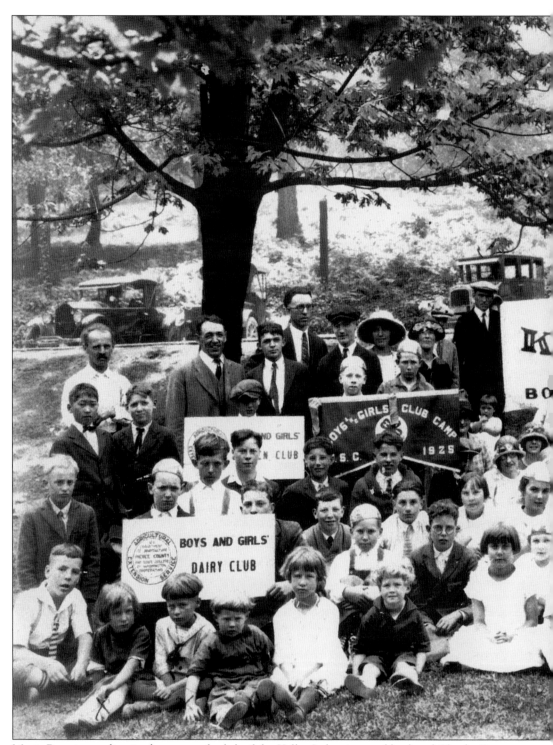

Marie Baur is standing in the rear to the left of the Kelley Lake sign, and husband Charles Baur is behind her. Their six children, Marie, Henry, Herman, Helen, Tony, and Carl, are seated on the ground on the left side of the photograph. The Baur family had leased land at the Kelley Farm

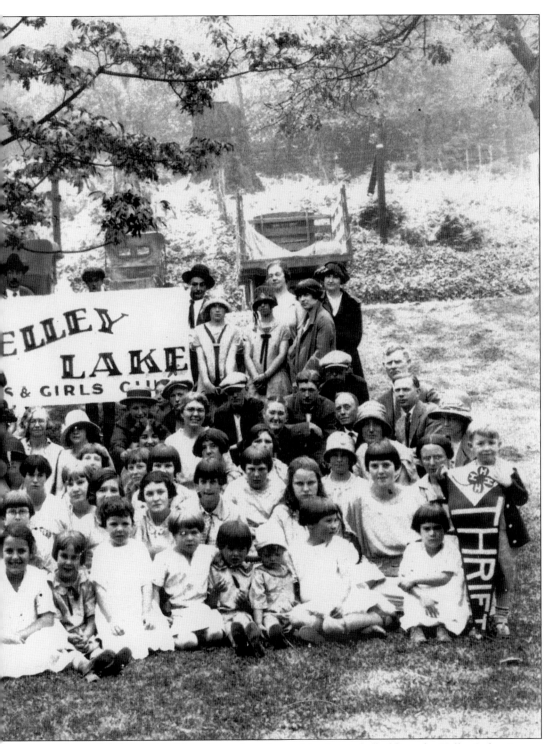

and raised dairy cattle. Also pictured are James Vandermark (holding the Kelley Lake sign on the right), Walter Vandermark (standing behind the sign to James's right), and Amanda Vandermark (with her head in front of the sign on the left side). (Walter Baur.)

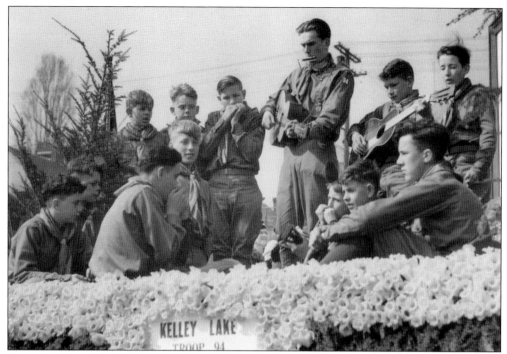

Participating in the 1938 Daffodil Festival Parade, members of Kelley Lake Boy Scout Troop 94 practice playing campfire songs on guitars and harmonicas while they wait aboard their club float for the parade to begin. (Tacoma Public Library, Richards Studio, no. D7160-10.)

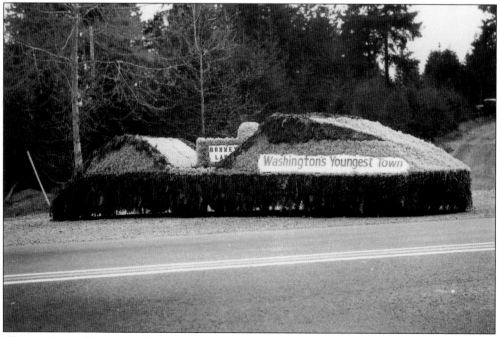

The residents of Bonney Lake wasted no time in advertising their new status as Washington's newest town. They entered a float in the 16th annual Daffodil Parade of April 9, 1949, just six weeks after officially incorporating as a town. (City of Bonney Lake.)

Many of the state's Finnish pioneers came to Washington to work in the coal mines in the foothills. When some decided to move to the plateau and take up farming, they formed their own little community, locally referred to as Finlandia. The Buckley Finn Hall, established in 1918, is the last remaining Finnish hall in Washington. This photograph shows, from left to right, members Armas Peterson and Elmer and Saima Hyppa. (Elmer Hyppa family.)

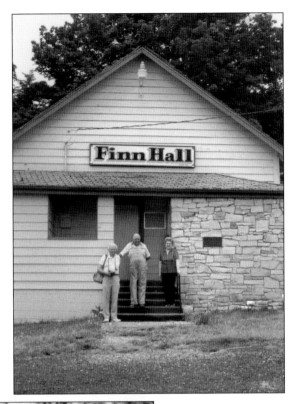

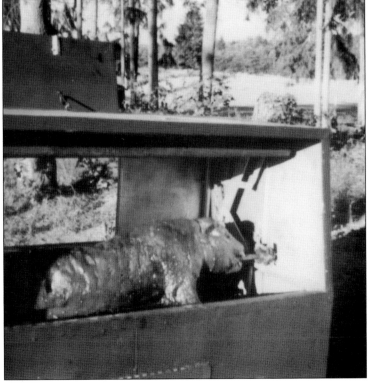

Finn Hall was the community center for the local Finnish residents, but it was also well known for its celebration of summer at the Juhannus, or summer solstice festival. Programs, dances, lots of music, and great food were enjoyed by the hundreds who would come from all over the Northwest. This photograph shows a whole roasted pig being prepared for the event. (Elmer Hyppa family.)

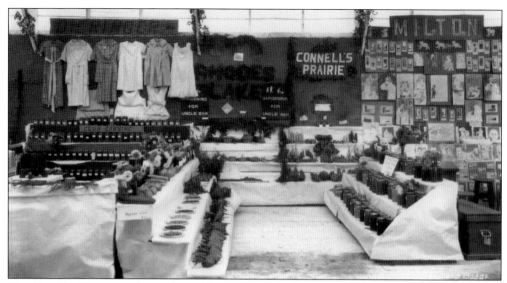

The Puyallup Fair started as a three-day event in October 1900. It continued to grow and was renamed the Western Washington Fair by 1913. The products of the communities of Dieringer, Rhodes Lake, Connell's Prairie, and Milton are pictured in this October 1919 photograph. (Tacoma Public Library, Boland no. B2321)

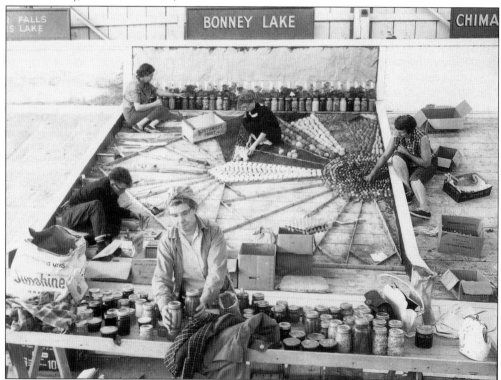

People from Bonney Lake work to set up an artful display of fruits, vegetables, and eggs for Puyallup's Western Washington Fair. It would typically include products that were produced in the area. In 1960, the projected record-breaking attendance was over 400,000 people. (Tacoma Public Library, Western Washington Fair Collection Series: 1960-40.)

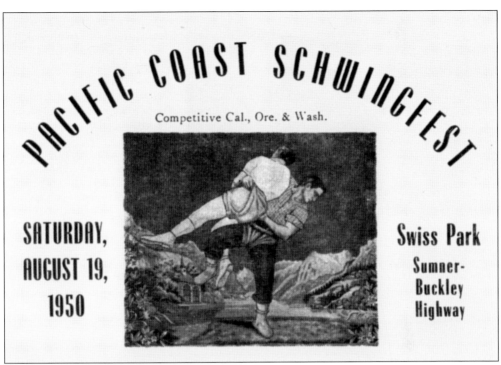

PACIFIC COAST SCHWINGFEST

Competitive Cal., Ore. & Wash.

SATURDAY, AUGUST 19, 1950

Swiss Park
Sumner-Buckley
Highway

On August 19, 1950, the Swiss Sportsmen's Club hosted its first Schwingen (Swiss-style wrestling) competition at the Swiss Park in Bonney Lake. Wrestlers, fans, and observers from all over the West Coast converged on the small town of Bonney Lake to celebrate an age-old tradition. (Swiss Sportsmen's Club.)

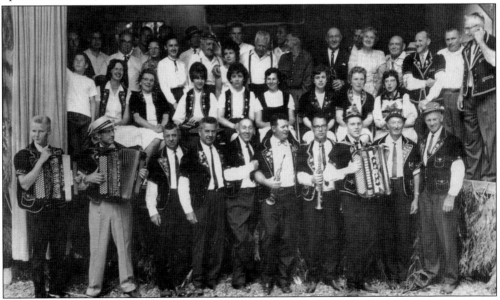

Wherever the Swiss gather, music is always a part of the program. Landler is the lively folk music, played with accordion, clarinet, and bass, performed for traditional dances. This 1964 Musicfest was held at Swiss Park in Bonney Lake and was the Second Pacific Northwest Swiss Music Festival. This music festival is a separate event from that depicted on page 79. (Swiss Sportsmen's Club.)

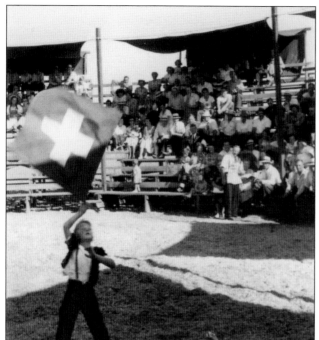

Six-year-old Donnie Ulrich demonstrates flag twirling at a Swiss Park competition in Bonney Lake in 1956. Although this activity had its roots in Switzerland during the Middle Ages, when it was practiced by the urban guilds, it was Swiss mercenaries who had been serving in foreign European armies who returned home to Switzerland with the skill. (Swiss Sportsmen's Club.)

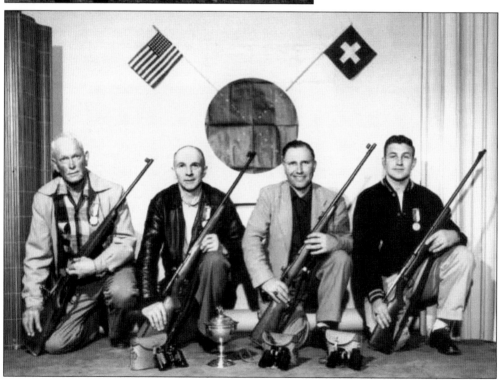

The first pit for target shooting was installed in 1951, and a shooting shed was added in 1954. Competition is offered in small and big bore, trap shooting, pistol, and crossbow. The Swiss Park Rifle Club Champions in 1954 are, from left to right, Isidor Ochsner, John Emmenagger, Louis Imhof, and Albert Burgener. (Swiss Sportsmen's Club.)

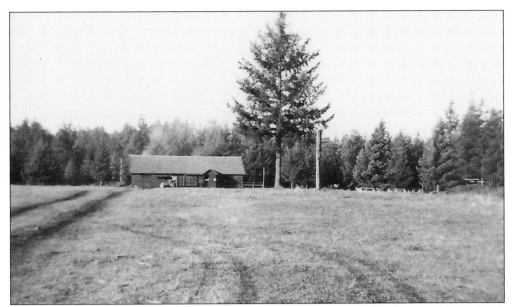

When the Swiss Rifle Club of Tacoma could no longer use the Kaelin farm in Orting for its practice and tournaments, it needed to move to a more sparsely populated area. In 1947, the club purchased 10 acres of land in what was to become Bonney Lake. The following year, the clubhouse was built and another five acres was purchased. (Swiss Sportsmen's Club.)

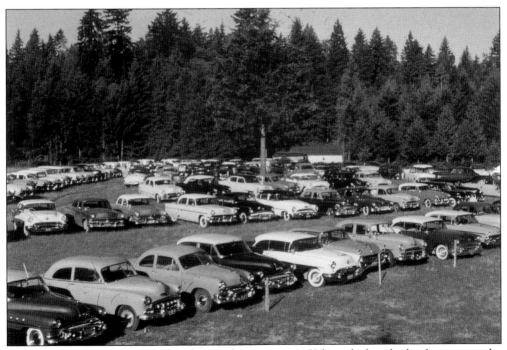

The Swiss Sportsmen's Club annual festival in August 1953 brought hundreds of visitors to the park in Bonney Lake to celebrate their Swiss heritage. The large grassy field was used as a parking lot, but it looks more like a lot for classic cars. (Swiss Sportsmen's Club.)

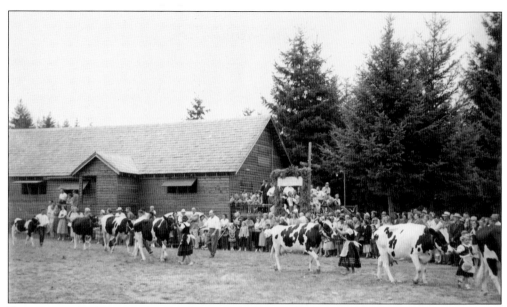

Festivities at the August 1953 event began with the parade of Holstein cattle at Swiss Sportsmen's Club in Bonney Lake. Led by young girls dressed in traditional Swiss finery, the influence of the Swiss dairy families in the state is evident. (Swiss Sportsmen's Club.)

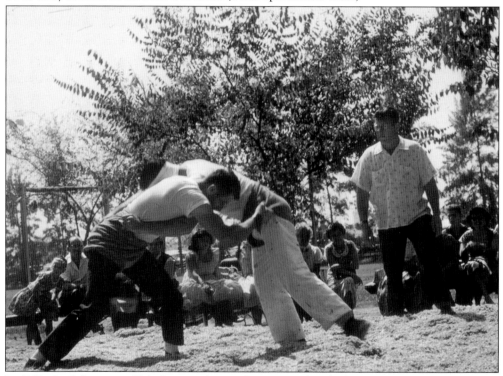

In 1958, the Schwingen Club, Swiss-style wrestling, merged with the Swiss Park Rifle Club, thus forming the Swiss Sportsmen's Club. The history of Schwingen goes back 1,000 years, but the sport today continues to promote a friendly spirit of competition and camaraderie and provides a tie that still binds the Swiss community together. (Swiss Sportsmen's Club.)

Former president of Switzerland Ludwig von Moos and wife Helena were visiting Washington DC on official business in 1971 but extended their stay and crossed the country to visit with family in Washington State. The uncle of Betty Baur, President von Moos visited the Swiss Sportsmen's Club in Bonney Lake in May 1971. (Betty Baur.)

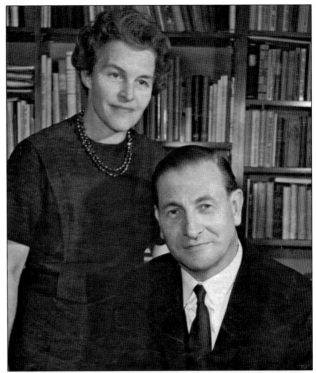

A Musikfest highlighted the choral groups from communities along the west coast from California to Washington. This 1970 gathering, flanked by men on the long wooden alphorns, was hosted by the Tacoma Swiss Sportsmen's Club at the Swiss Park in Bonney Lake. (Swiss Sportsmen's Club.)

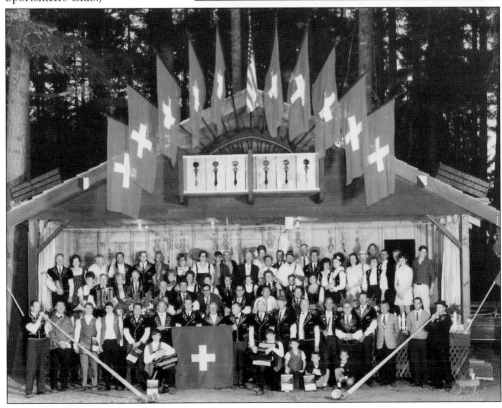

Mayor Carle Whisler of Bonney Lake appointed members to a local library board in 1972 in an effort to bring a library to the town. A grant was applied for and approved for "a demonstration of system-oriented public library service" for a period of three years. A temporary modular building was brought in and placed at the corner of Locust Avenue and Old Buckley Highway. (Carol Ferguson.)

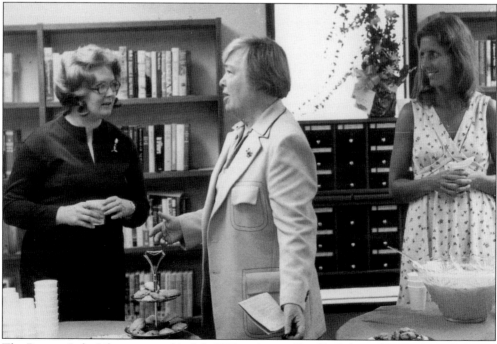

The Bonney Lake Library opened in July 1975 and was officially dedicated by Dr. Dixie Lee Ray in September. Ray had served as head of the Atomic Energy Commission and for a brief period as assistant secretary of state for oceans, international environment, and scientific affairs. In March 1976, Ray announced her candidacy for governor, and in November, she became Washington's first female governor. (Carol Ferguson.)

Seven

PLATEAU MIGRATION

During the early 1900s, several families moved from the mining communities in the foothills to establish farms on the plateau. The Finns concentrated in the area now known as Bonney Lake's East Town. There was also a significant influx of Swiss on the plateau, with many of them engaged in dairy farming. By the time the 1930s arrived, America was experiencing great economic change and massive movement by many segments of the population. The stock market crash of 1929 left massive unemployment, lost savings and investments, and bank foreclosures on homes. The devastating drought that hit the Midwest hung for years and turned lush, productive farms into dry, dusty wastelands.

The plateau experienced an increase in population during this period. Many families packed all their belongings into trucks and moved west in search of a new life. Much like their predecessors several decades earlier who came west by covered wagons, these emigrants from the dust-blown states to the east were modern-day pioneers. They found that land in the fertile Puyallup, Stuck, or White River Valleys was expensive. This contrasted sharply with land that was available on the plateau, which was still largely undeveloped and difficult to reach. The names of some of those families that arrived ready to start a new life in a vastly different part of the country are familiar to many in the area: Hyppa, Bowen, Thieman, and Crane are just a few.

Many of these transplanted farmers found that life in a new place required a change of occupation, and the logging industry provided many with new careers. Before long, the decade of the 1940s had arrived and with it a global conflict that touched every family in some way. Some people found work in the shipyards in Tacoma and would take a bus from the plateau to the tide flats.

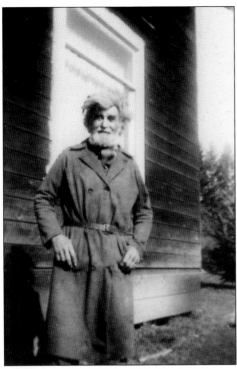

Jim Hardman is seen beside the Cecil Frazier home at Victor Falls in the late 1940s. Born in England, he had a vast knowledge and interest in racehorses, but he chose to live the life of a recluse near Victor Falls on Fennel Creek. (Don Frazier.)

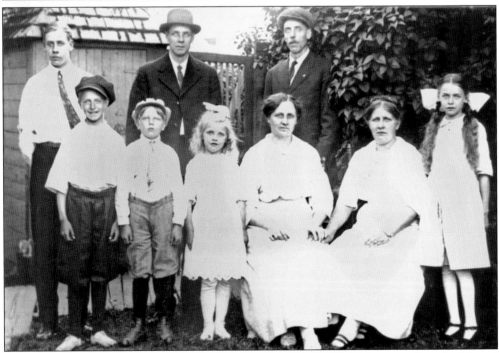

The John Hyppa family poses for a photograph around 1915. John immigrated to the United States in 1900 from Finland. He went to work in the coal mines of Melmont for the Northwest Improvement Company, a subsidiary of Northern Pacific Railway. Earning enough money, he was able to have his wife, Sanna, and son, Charley, join him in 1903. (Elmer Hyppa family.)

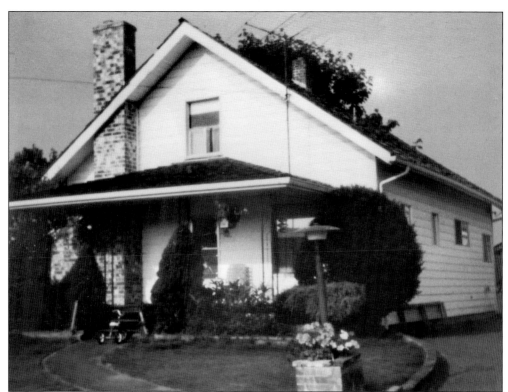

This 1983 photograph is of the home that John Hyppa built about 1920 on what is now 234th Avenue East. He had earned enough money in the coal mines to purchase 40 acres of land in an area where other Finns had also settled. Like many fathers in the mines, he wanted a different life for his children. (Elmer Hyppa family.)

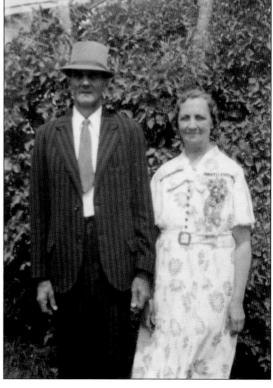

John and Sanna Hyppa are pictured prior to Sanna's death in 1941. She came to this country through Ellis Island in 1903 as a young wife and mother of a three-year-old. She was destined for Carbonado, Washington, to meet her husband, from whom she had been separated for three years. (Elmer Hyppa family.)

83

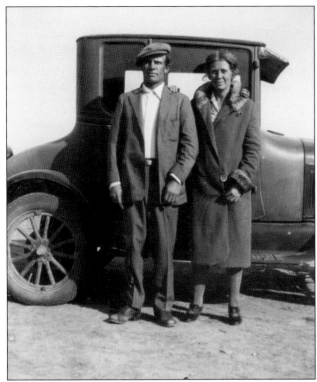

Pictured are Oscar and Goldia Bowen, who lived near Gary, Colorado, before 1934. Crop failures and a lack of other work opportunities were hard on the family. Oscar's brother Jess convinced them to move to the lush green state of Washington, where life may not have been as harsh as on the eastern plains of Colorado. (Bowen family.)

Jess and Charlotte Bowen made the journey from Washington back to Colorado. Jess convinced members of his family to join him and Charlotte in Washington. They are seen standing before their canvas-covered truck that was used to transport many of the family members to the Evergreen State. (Bowen family.)

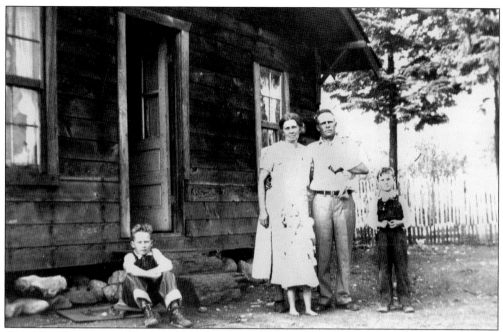

Oscar found five acres of land with a partially finished house and a beautiful valley view that was up the scary, crooked road of Elhi Hill. There was no electricity, water, or telephone available. Oscar and Goldia with their children—from left to right, Virgil, Betty, Lorraine (in Oscar's arms), and Clarence—stand outside their home with log steps and a loose stone foundation. (Bowen family.)

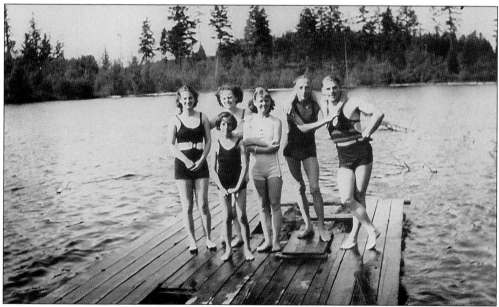

Bonney Lake during the summer of 1936 was a great swimming hole for Werner Stroeve (right), his little sister, Elaine (second from left), and several of their friends. There were no houses or boats, and very few people frequenting the lake. They could paddle or pole along the shore on a raft of logs and old lumber. (Elaine Stroeve Farrar.)

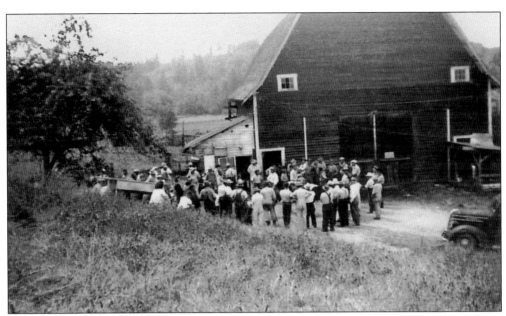

Following the stock market crash of 1929, Fred Haase sold his farm on Old Buckley Highway and moved to the shore of Lake Tapps. Nearly 20 years later, the owner, Loren Burbank, held an auction at his barn on Old Buckley Highway on July 16, 1948. The Burbank farm was located behind the current Target store site. The Farmer's Auction Market of Kent conducted the on-site auction of farm equipment and dairy cows. Several pages of inventory were listed, with items that ranged from a 25¢ rake to a bull for $372.50. (Both, Bowen family.)

Pictured at the Pat and Sally Seeley home in 1947 are Bud and Florence Seeley and their friends. Hoping to go for a spin in the 1923 Model T, Elvin Seeley is attempting to crank up the engine while Bud waits in the driver's seat. Although the Seeleys moved into their home in 1943, former owners claimed it had been built at least 75 years earlier. (Elvin Seeley.)

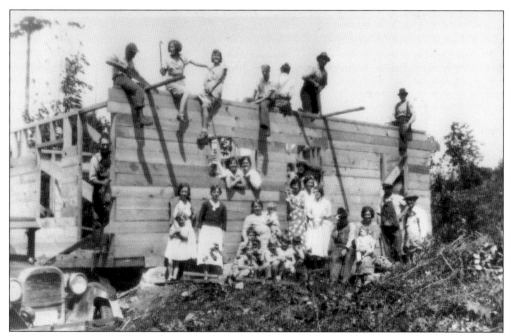

In 1933, James C. Hall purchased six acres in what is currently known as the Bonney Lake downtown triangle. With the help of neighbors and friends from their church in Puyallup, the walls of their new house at the corner of Old Buckley Highway and Main Street were quickly erected. (Barbara Hall Clark.)

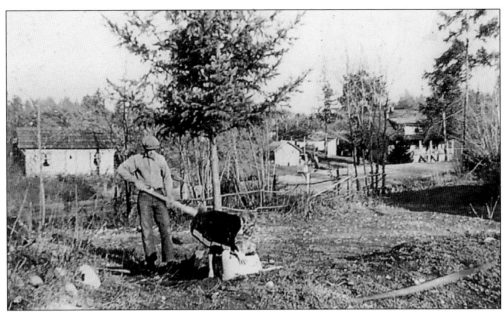

James Hall and his daughter Barbara are working to prepare the yard for planting a lawn. He is shoveling the stone-laden dirt onto a screen. The filtered dirt is used as the topsoil for the lawn. (Barbara Hall Clark.)

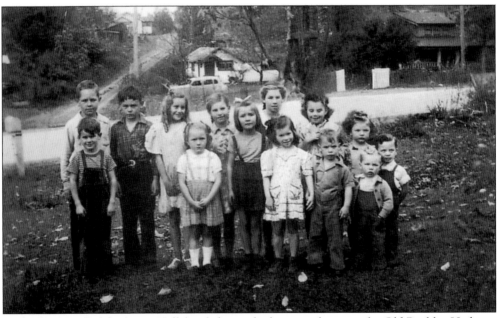

In the front yard of the James Hall family home, looking north across the Old Buckley Highway near the intersection with Main Street, children gather for a photograph at the birthday party for Marilyn Hall (second row, third from the left). Her brother Jimmie is at far right in the first row. Other children pictured are from the Martin, Tuthill, Gonseth, Filkins, Phillips, and Coburn families. (Barbara Hall Clark.)

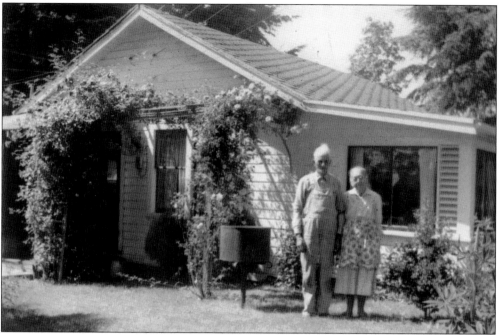

H. Eugene and Mary Almeda Crane stand before their house on Vandermark Road, now known as 214th Avenue. The couple arrived on the plateau in 1926 from Rochester, Minnesota. They had two daughters—Luella Crane and Vivian Crane (Moulton). (Sue Moulton Hahto.)

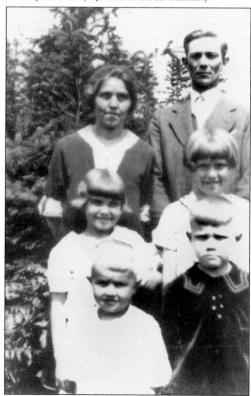

Roy and Vivian Crane Moulton were given land on which to build their home by Vivian's father, Eugene Crane. He made it a point to give a portion of his land to each of his grandchildren, too. The photograph is of Roy and Vivian and their children— from left to right, (first row) Kenneth and Wilbur; (second row) Mildred and Beth. (Sue Moulton Hahto.)

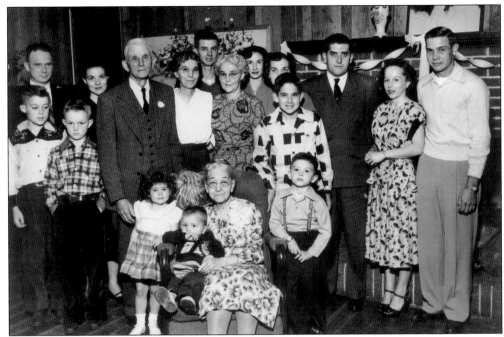

In 1952, the 60th wedding anniversary of H. Eugene and Mary Almeda Crane was celebrated by many friends and family. Eugene, a retired carpenter, had previously dabbled in other careers as a farmer and a salesman of medicines and extracts. The photograph includes family members of the Crane, Goldsberry, Moulton, and Thieman families. (Sue Moulton Hahto.)

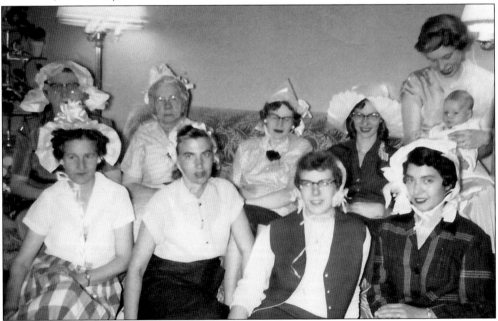

Gertrude Wheeler hosted a baby shower for Barbara Hall Babcock when she returned home for a visit in February 1955. Barbara was expecting her first son, Mark, at the time. Guests at the shower played games and made impromptu baby bonnets. Some of the ladies posed for a photograph displaying their millinery skills. (Barbara Hall Clark.)

The home of John C. Stroeve in 1932 was built on acreage that had previously experienced a forest fire. It was a few years before the luxuries of indoor plumbing and electricity came to the Bonney Lake area of the plateau. When Stroeve finally had the opportunity to hook up to the power grid, it cost him a whopping $400. The house in the photograph was located where the current Windermere Real Estate office sits. (Elaine Stroeve Farrar.)

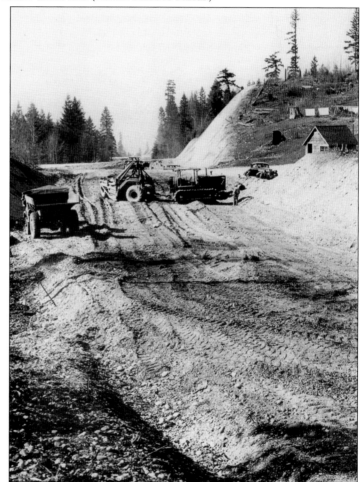

A tractor and scraper work in gravel at the top of Elhi Hill about where the Arco station and the Dairy Queen are located. The property on the right belonged to John Stroeve. His car can be seen on the right near a small building from which he would sell coffee and snacks to the road crew. (Washington State Department of Transportation [WSDOT] contract 2465, no. 253.)

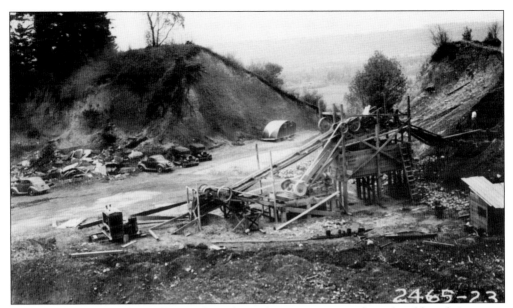

This view shows Don Shotwell's gravel-crushing plant in operation along the old road. Access to the garbage dump was located across the old concrete road from Shotwell's. A part of the Puyallup River Valley between Sumner and Orting can be seen in the distance. (WSDOT contract 2465, no. 266.)

This image shows a section of the completed Primary State Highway (PSH) 5. Rounding the turn of the highway, the house in the center is the James Hall home, located on the Old Buckley Highway at what is now Main Street. The area to the right of the house is the current downtown triangle of Bonney Lake. (WSDOT, contract 2465, no. 250.)

The old paved road shows a series of closely connected hairpin curves winding around the points of the hills and into the small canyons that indent the hillside. The Elhi Hill section of the Sumner-to-Buckley part of PSH 5 had been noted for many years for the large number of sharp curves making a snake-like road. (WSDOT contract 2465, no. 251.)

The old concrete pavement shows the large number of curves that were eliminated by using a lot of fill. The shorter distance created had no appreciable increase in grade. The average roadway width of 18 feet on the old pavement was increased to 22 feet on the new road. (WSDOT contract 2465, no. 260.)

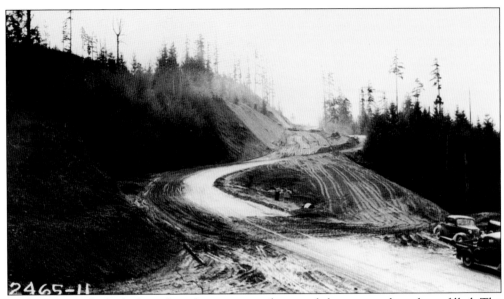

In the picture, the high slopes have been cut way down and the canyons have been filled. The pavement on the old road can be seen crossing and recrossing the new construction, which eliminated a multitude of dangerous curves. (WSDOT contract 2465, no. 254.)

Looking toward Sumner from the top of the hill, the nearly completed embankment along the new highway between Sumner and Bonney Lake is seen in the lower right of the picture. The white area with the two trees is not snow but material eroded from the slopes by the winter rains. The winding road in the left of the picture is the old Elhi Hill Sumner-to-Buckley road and part of the earlier Naches Trail. The county poor farm shows faintly through the fog in the background. (WSDOT contract 2465, no. 246.)

Eight

A Town Is Created

When Kenneth Simmons and his wife, Bertha, crossed the valley and climbed Elhi Hill to the plateau, he was enchanted by the trees, lakes, and landscape. He bought 160 acres of land around little Bonney Lake from Pete Logan, a renowned announcer for the professional rodeo circuit. With the eye of a developer, Simmons saw the potential value of creating a recreational haven. He built a resort on the shores of the lake with a clubhouse, swimming area, high dive, and a wide sandy beach. With an old bulldozer, he carved roads through his forested land, going up and down the hills and around the lake. A major obstacle to further development was the lack of a potable water system. Though the majority of the residents wanted a dependable, communal water system, they could not legally float a bond to build a system unless they were incorporated as a town. Simmons thought that the name Bonney Lake would be appropriate since he was marketing his real estate on the lake by the same name, and it might also reflect his "bonny" Scottish heritage.

Whether Simmons initiated the drive to become a city, or if it was the residents who had lived there before the Simmonses' arrival, the story varies with the telling. Finally, on February 28, 1949, the Town of Bonney Lake was formed with a proclaimed population of 327. Simmons was elected mayor and continued to serve in that position for the next 12 years. Within little more than a year, Washington's newest town had its own water system, new roads, expanded electric lines, refuse disposal, and telephone service, and Ken Simmons was selling real estate.

This photograph of Primary State Highway 5, from Sumner to Buckley, looking east on Elhi Hill, was taken on October 15, 1946. Where the power lines still cross the highway, the future development known as Sky Island would be to the right, and Ascent Park would be just up the highway to the right. (WSDOT, Simmer no. 1210.)

The view that identified Bonney Lake was the vision of Mount Rainier as seen through the gap once the top of the plateau was reached. Framed by evergreen trees on both sides of the road, it was a breath-taking site. Primary State Highway 5 later became known as State Route 410. (WSDOT, Simmer no. 1211.)

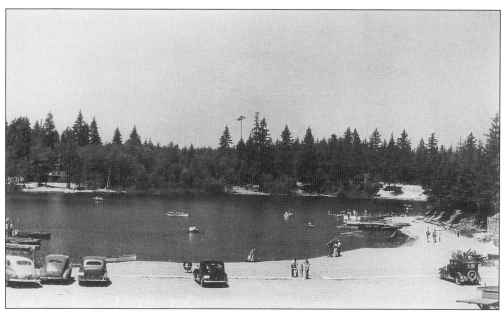

Ken Simmons bought 160 acres on Bonney Lake in 1946 and built a resort to promote his real estate sales. Fourth of July festivities in 1950 were marred by the tragedy of two young brothers, Dennis and Michael Shadle, ages 8 and 7, of Puyallup, who drowned when they stepped off a ledge into deep water. The popular resort closed, never to reopen. (Greater Bonney Lake Historical Society.)

From left to right, Doug McCoy, Gary Tidball, Paul Stone, and Dennis Wiley are admiring a brand new Hopalong Cassidy bicycle about 1952. In 1949, Hopalong Cassidy became the first network Western television series, featuring the black-garbed cowboy as the hero. It was so popular that by 1950, more than $70 million in "Hoppy" products were manufactured. (Doug McCoy.)

Pictured about 1956 are Lola McCoy, who went on to become the Sumner High School Daffodil Princess 10 years later; Doug McCoy, who later ran as a candidate for mayor of Bonney Lake; and little Steve McCoy at the family home on Eighty-fourth Street in Bonney Lake. (Doug McCoy.)

In 1956, Doug McCoy performed on stage before the public for the first time at the Liberty Theater in Puyallup. He had entered a talent contest impersonating Elvis Presley and singing "That's Alright Mama." Doug went on to perform at the Elks Club and on KAYE radio in Puyallup. (Doug McCoy.)

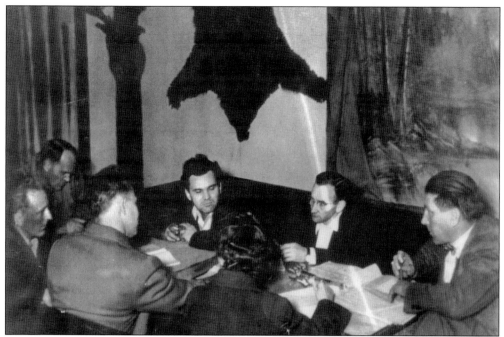

The first Bonney Lake town council met in the Ken Simmons clubhouse on the shore of Bonney Lake in 1949. The first order of business was to fund a municipal water system. Members are, clockwise from top left, Bob Wheeler, Curly Maddox, Pop Hiles, Mayor Ken Simmons, Gertrude Wheeler, Clarence Roberts, and Alvy Simnit. (City of Bonney Lake.)

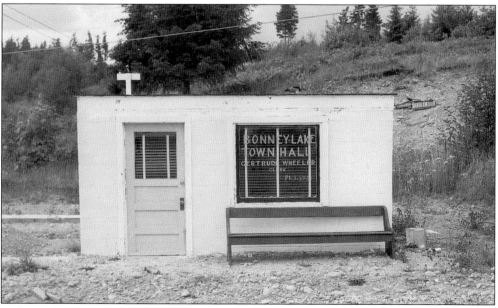

In the early 1950s, the Bonney Lake Town Hall not only served the administrative needs of the fledgling town, but on Sundays it was used for teaching Sunday school classes. This building was originally located near the current Public Safety Building on Old Buckley Highway. (City of Bonney Lake.)

Kenneth Simmons, Bonney Lake's first mayor, served in that position from 1949 till 1966. Prior to his coming to Bonney Lake, he served as the mayor of Milton and was also a Washington State legislator. (City of Bonney Lake.)

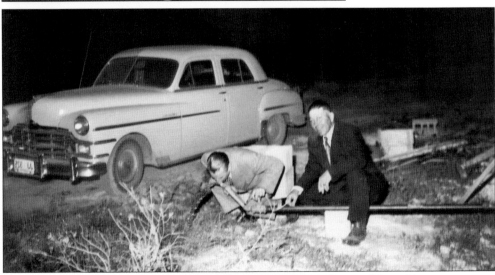

On July 7, 1950, Bonney Lake held a big celebration for the completion of the public water system. Sen. Henry "Scoop" Jackson arrived too late for the festivities but still managed to sample the water and convey his congratulations, in spite of the late hour. (City of Bonney Lake.)

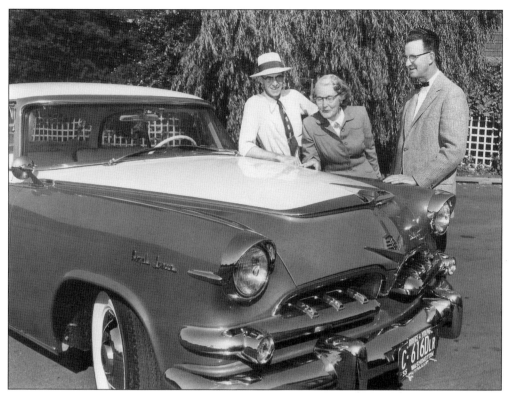

Mrs. Ralph Chantry was the happy winner of a brand new 1955 Dodge Custom Royal Lancer. It was the grand prize in a U&I Sugar contest she had entered. She and her husband also received an all-expenses-paid trip to Hollywood. The prize came at a most opportune time. They had recently moved into their new Bonney Lake home but had just taken their car in for repairs. (*Puyallup Valley Tribune*, 8-11-55-alt. photograph and article.)

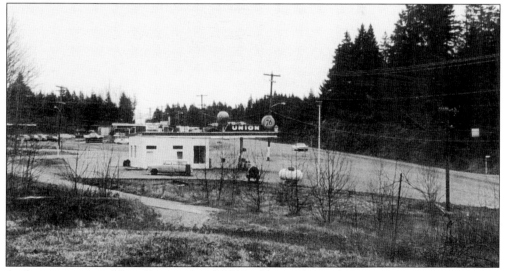

At the intersection of State Route 410 and Old Buckley Highway, the remnants of the first concrete road built in 1920 up Elhi Hill are still visible in the foreground of this 1960s photograph. The old Union 76 gas station has been replaced with an Arco. (City of Bonney Lake.)

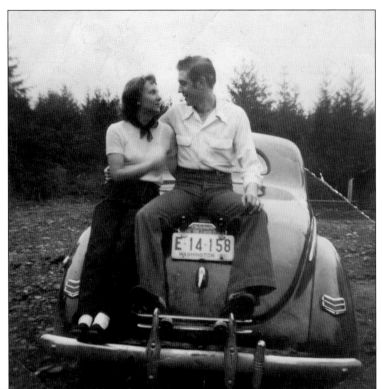

Duane Tidball and his wife, Irys, moved to Bonney Lake in 1951. An enterprising young man, he worked several jobs for the Town of Bonney Lake, including garbage collector. That lasted until the truck that was used to haul the garbage was inspected by the sheriff. It was in such bad shape that the sheriff kept the truck, and the town council decided to contract out the garbage pickup service. (Connie Tidball Swarthout.)

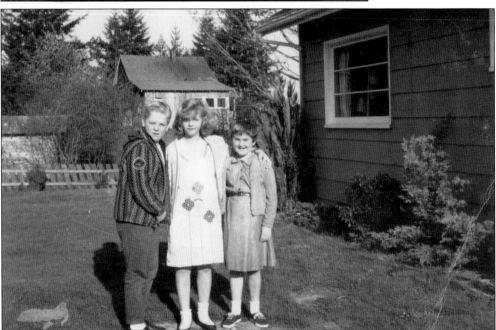

From left to right, Randy and Connie Tidball and Karen Wheeler are pictured outside the Tidball home about 1966. The building on the hill behind is where the current office building stands at Ninetieth and Main Streets, across the street from the Interim Justice Center in downtown Bonney Lake. (Connie Tidball Swarthout.)

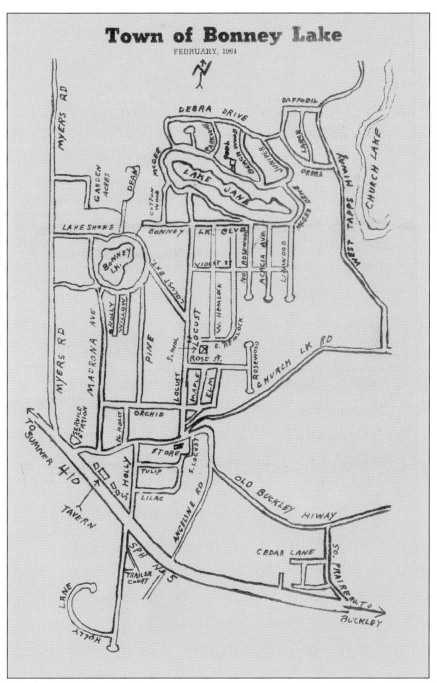

Town of Bonney Lake

FEBRUARY, 1961

In 1961, twelve years after incorporation, the Town of Bonney Lake had more than doubled its population and had expanded its boundaries. The streets were laden with the names of plants and trees in this hand-drawn town map. The town had three zones: commercial, which was all property within 200 feet of Old Buckley Highway and the current State Route 410; residential zone 2, which allowed mobile homes and recreational buildings; and residential zone 1, which was for single-family residences. Permit fees for the construction of commercial or residential buildings were $20. (Greater Bonney Lake Historical Society.)

In 1971, the new Bonney Lake City Hall reflected the type of community that Bonney Lake was. The retention of the natural forest canopy reinforced the reality of a recreational community. The original entrance to the city hall was later changed to the current centrally located entry. (City of Bonney Lake.)

Mayor Allan Yorke served from 1973 to 1976. Although his tenure was brief, Yorke provided a unifying influence for a town that had become divided on many issues. Bonney Lake changed the name of its lakefront park on Lake Tapps to Allan Yorke Park to commemorate him. (City of Bonney Lake.)

When Mayor Allan Yorke passed away in July 1976, councilman Steve Flaherty was appointed to serve the remainder of Yorke's term. In November of that year, he ran for the office and was elected for a four-year term. The town's youngest mayor at age 26, Flaherty juggled marriage, fatherhood, and enrollment at the University of Washington and held a part-time job in the university bookstore. (Greater Bonney Lake Historical Society.)

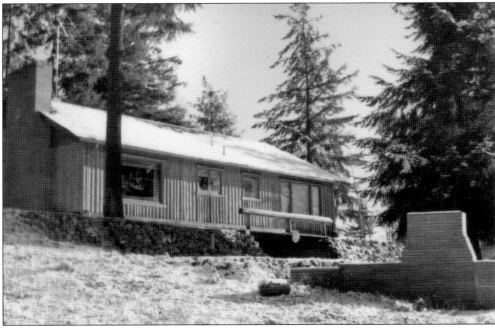

The Carstens cabin on Lake Bonney was designed and built around 1947 as a retirement home. When Mr. Carstens, of Carstens/Hygrade meatpacking fame, was transferred to Spokane, the house was sold to Virginia Lunn in 1956. The cabin was constructed from logs harvested in Bonney Lake. They were set vertically, creating a rather unique appearance. (Chris Lunn.)

Virginia Lunn shares a quiet moment with her new granddaughter, Annalisa, in her Lake Bonney home. Virginia and her business partner, Kathleen Foshaug, bought the Ketring studio by the Liberty Theater in Puyallup and first called it Foshaug at Ketrings Photo Studio. (Chris Lunn.)

Displaying a bit of humor, this handmade invitation for their 1957 housewarming party was created by Virginia Lunn and her friend and business partner, Kathleen Foshaug. Both women were professional photographers for the state legislature. They started a small studio in North Puyallup and eventually moved to Puyallup, where they owned and operated the Foshaug Photography Studio. (Chris Lunn.)

The winter of 1963 came early and turned Bonney Lake into a snowy wonderland, muffling all sound and bringing a hush to the lakeside. Virginia Lunn's log cabin can be seen at the edge of the forest on the far side of the lake. (Chris Lunn.)

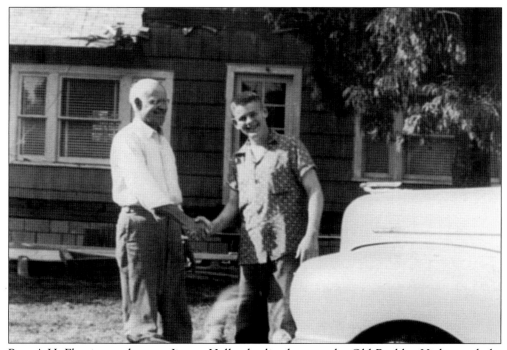

Rev. A.H. Fleming and young Jimmy Hall, who lived across the Old Buckley Highway, shake hands in front of the Fleming home. Jimmy bought his first car from Reverend Fleming. (Hulan Fleming.)

In this 1950 photograph, Rev. Albert H. Fleming carries a load of firewood at his house in Bonney Lake, located along the Old Buckley Highway. The highway is a gravel road, and the house seen across the street sits where CJ's Deli is currently located. (Hulan Fleming.)

Cutting firewood in 1951 are Hulan Fleming (left) and his father, Rev. Albert Fleming. Hulan had always shown artistic talent, so his parents signed him up for a commercial art course while he was still a student. He is now a nationally acclaimed artist. A print of his first painting is slated to hang in Bonney Lake's new Interim Justice Center. (Hulan Fleming.)

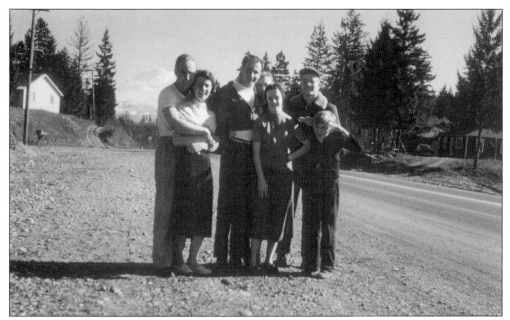

From left to right, Hulan Fleming, Patty Pierce, Vince and Lois Fleming, Al Nyhuis, and Cliff Butler (also known as Baby Gramps, the musician) stand along State Route 410 in this photograph taken about 1955, with Mount Rainier visible through the gap in the background. The house on the left is the Edberg home, formerly located at State Route 410 and Main Street. (Hulan Fleming.)

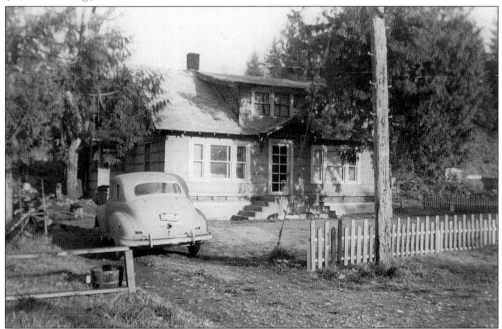

The Rev. Albert Fleming home can be seen in this 1951 photograph on Old Buckley Highway, opposite the location of the current Main Street. The Flemings kept a family of goats staked to the hillside so they would eat the brush and brambles and keep the area clean. (Hulan Fleming.)

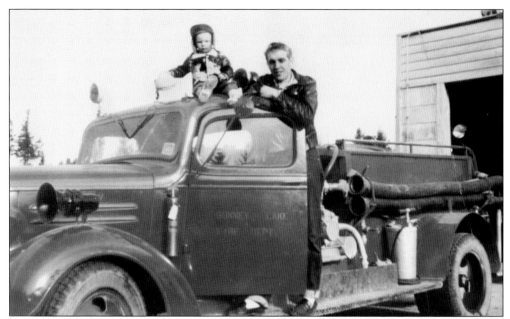

Duane Tidball and his son, Randy, perch atop the old Bonney Lake 1939 Chevrolet fire engine. In 1954, Duane was appointed chief of the volunteer fire department. Mayor Ken Simmons had found a used fire engine that could be obtained for next to nothing. Letters on the door very faintly read Bonney Lake Fire Department. (Connie Tidball Swarthout.)

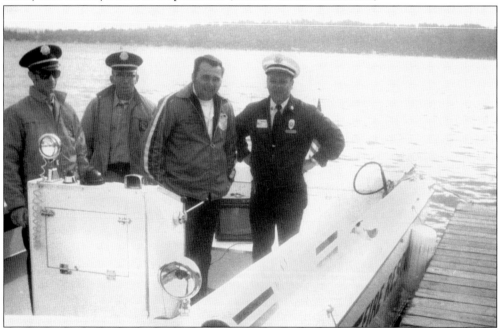

The fire rescue boat and crew of the Bonney Lake Fire Department assisted in several emergencies during the August 1985 Seafair unlimited hydroplane races. They earned the praise of the boat drivers and officials of the event. Pictured are, from left to right, Lt. Arnold Schager; Lt. Frank Chandler; George Henley, champion driver of the *Pay N Pak*; and chief Alden Dobson. (Bonney Lake Fire Department.)

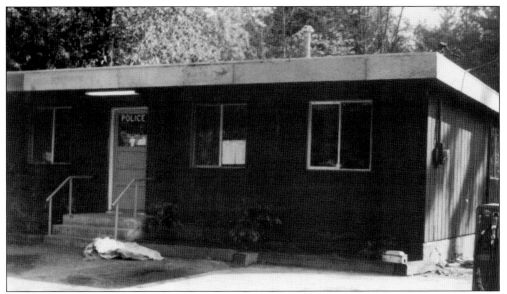

In 1961, the Town Hall of Bonney Lake was located at 18421 Old Buckley Highway. When it moved in 1965 to share the location of the new fire station at the corner of Locust Avenue and Bonney Lake Boulevard, the police department moved into the vacated building. Two jail cells were later added in the basement as well as restrooms and offices. The structure was burned down in 1992 to make way for the Public Safety Building. (Don Frazier.)

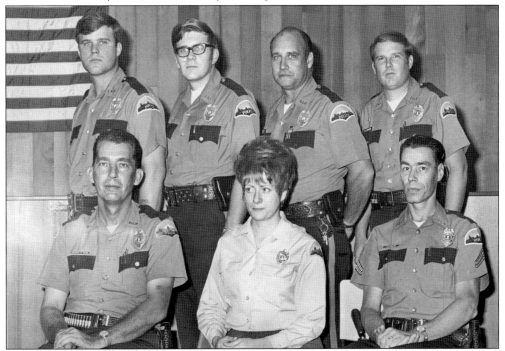

When the city was incorporated in 1949, Fred Corelle was appointed the first town marshal. He carried a badge and cane, which he would use on misbehaving children. This is a 1971 photograph of the police department under the leadership of chief George Webb (first row, left). Also seen is rookie Don Frazier (second row, right), future Bonney Lake police chief. (City of Bonney Lake.)

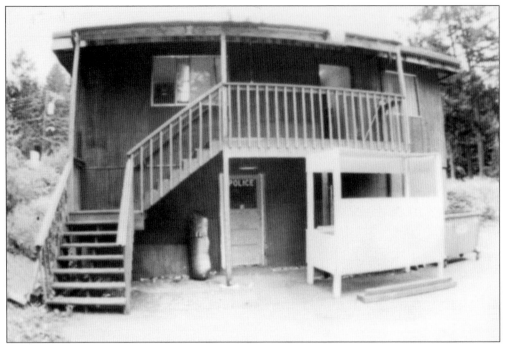

While the new Public Safety Building was under construction, the interim location for the police department was in an old building next-door. Today, that building is the home of the Bread of Life Food Bank, directed by Stew Bowen. (City of Bonney Lake.)

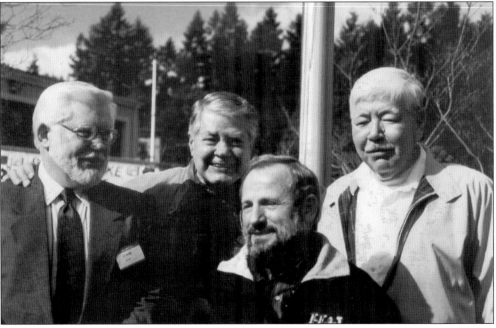

A rare photograph of four former mayors of Bonney Lake standing together and participating in the festivities at the dedication ceremony of the new Public Safety Building on the Old Buckley Highway was taken in 1991. They are, from left to right, Rex Pulfrey, Vern Strong, John Pedroso, and Carl Whisler. (Don Frazier.)

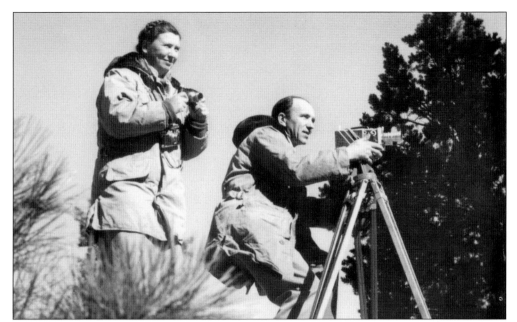

In 1959, Bonney Lake became home to retirees Alfred and Elma Milotte, world-renowned wildlife photographers. The couple received six Academy Awards for their photography in Walt Disney's nature films. The first was the 1948 movie *Seal Island*, filmed in Alaska. Their work often took them to faraway, exotic locations like Africa and Australia. This photograph was taken during a shoot at the Grand Canyon. (Lawton Case.)

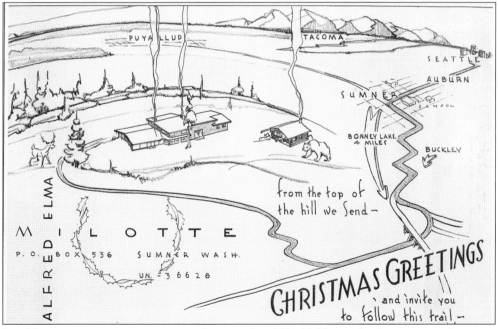

In addition to an amazing career in photography, Alfred Milotte also became an oil painter. Friends and family were sometimes the recipients of sketches, paintings, or drawings that might sometimes become part of a Christmas card, as seen here, also providing a map to their remote "island in the sky." (Lawton Case.)

The Milottes built their home on a knoll that provided views of unsurpassed beauty and magnificence, as seen through their living-room window. In order to perpetuate their passion for nature, the Milottes endowed a scholarship fund for those individuals who share their enthusiasm for exploring, chronicling, and spreading the magnificence of the wilderness through artistic communication. (Lawton Case.)

When Alfred and Elma Milotte purchased 160 acres of forested land overlooking the Orting and Puyallup Valleys in 1959, their love affair with nature continued. Even in retirement, the couple had movies, books, and lectures to work on. Following their deaths in 1989, their property was logged and developed into the neighborhoods of Sky Island and Panorama Heights. (Winona Jacobsen.)

Nine

PLATEAU COMMERCE

Business on the plateau and the area around Bonney Lake probably began with logging. The big trees of the plateau gave way to farmland, with hops, hay, potatoes, and other crops being cultivated. Numerous dairy farms were started as well as large poultry ranches that supplied the nearby towns with milk, butter, and egg products. As the population increased, more commercial ventures began, but they generally remained very rural, family-operated enterprises, such as a feed store in Marion, or small stores with a gas pump near Connell's Prairie, Lake Tapps, or Lake Bonney. There was no concentrated nucleus of businesses that would evolve into a town. With the highway improvements of 1940, easier access was finally achieved to the communities on the plateau. The recreational opportunities of the several lakes and of Mount Rainier provided an increase in the east-west traffic and enticed more people to seek property ownership away from the urban centers.

The incorporation of the Town of Bonney Lake in 1949 sparked a surge in growth, and a few businesses came with it, but the citizens preferred to maintain a non-urbanized recreational community. As a result, it was 1979 before the first fast-food establishment came to the area in the form of a Dairy Queen. In 1982, the large grocery store appeared in Bonney Lake with the openings of the Family Market and Safeway supermarkets. Retail businesses continued to increase, and the big-box stores began to appear. In 2010, the city took the first step to realize its goal of creating a more traditional, pedestrian-oriented downtown. The first building to start that process was built by the City of Bonney Lake and would become the Interim Justice Center on land that was formerly owned by Bob Wheeler, one of the original town council members in 1949.

The Frazier home, located at Victor Falls, was built in the early 1900s as a bunkhouse for workers in the sawmill that was built at the head of the falls. It was later owned and used as a residence by William Schroeder, William Shinn, and Cecil Frazier. (Don Frazier.)

Old-growth trees were once plentiful on the plateau, but a massive logging operation was conducted to make way for the Lake Tapps reservoir. Smaller sawmills in the surrounding area continued to clear the land and provide lumber. Charles Moriarty (left) and Albert Swint (right) are resting before a big tree they prepared for felling. (Dennis Moriarty.)

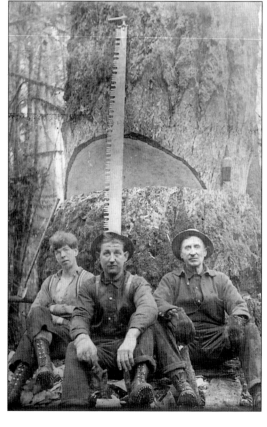

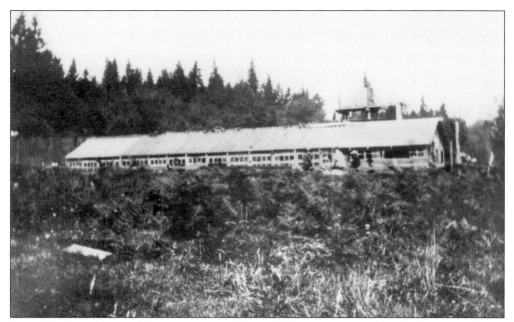

James Vandermark was able to grow vegetables and flowers year-round in the large greenhouse on the farm. He delivered his goods by horse and wagon to Buckley, Carbonado, and Wilkeson along a regular route. Later, his wagon gave way to a pickup truck, and the trek was much faster. (Vandermark descendants.)

By August 1940, Nick Perfield's fields near Buckley were among the last in western Washington still growing hops. Weather, insects, fluctuating prices, and downy mildew from Canada had made hop farming a losing proposition. By 1956, there were only three remaining hop growers in the area with a combined acreage of just 150 acres. (Tacoma Public Library, Richards Studio Collection, Series D10193-7.)

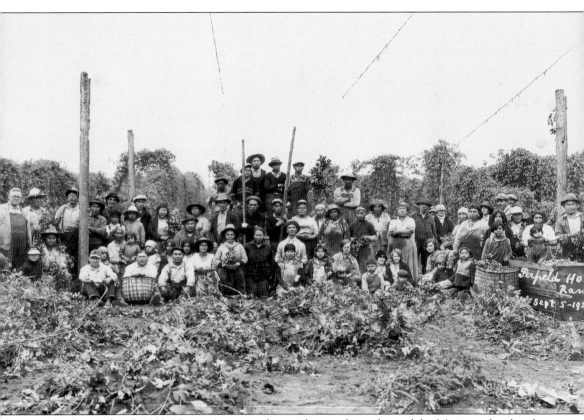

On September 5, 1923, Native American hop pickers and members of the Moriarty family take a break to pose for a photograph at the Perfield Hop Ranch. It was originally located north of 192nd Avenue East and Old Sumner Buckley Highway. The long poles held by workers in the center were stilts that were used by wire stringers or hop pickers. (Dennis Moriarty.)

In 1947, the Nicholas Perfield Hop Farm provided punch tickets to its hop pickers. It was an easy and efficient method for each picker to keep track of his daily volume and for the farmer to make payment at the end of the day or possibly the end of the season. (Bowen family.)

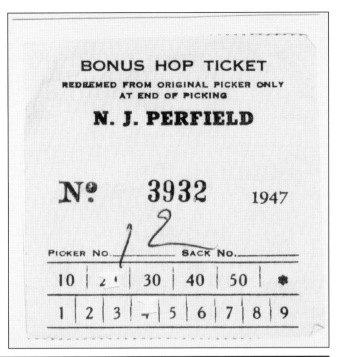

BONUS HOP TICKET

REDEEMED FROM ORIGINAL PICKER ONLY
AT END OF PICKING

N. J. PERFIELD

№ 3932 1947

PICKER NO. _____ SACK NO. _____

10	2	30	40	50	*			
1	2	3	4	5	6	7	8	9

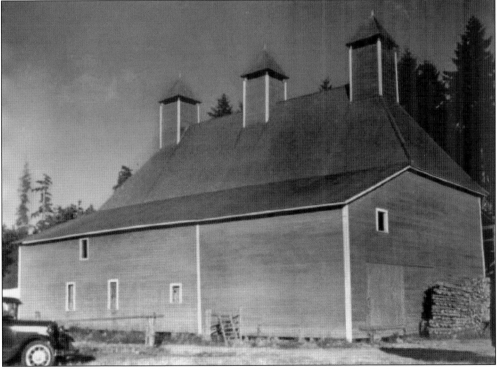

This hop barn on Nick Perfield's farm is actually a kiln, designed to dry the harvest of green hops by heating the air with a stove located on the ground level, while the hops lay on racks above. The roof towers were vents through which the hot air could escape. (Tacoma Public Library, Richards Studio Collection, Series D10193-6.)

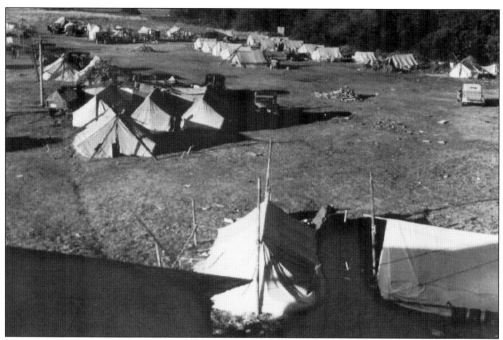

Nick Perfield's hop farm became the site of a tent city each September when the hop harvest would get underway. It was not uncommon for Native American pickers to erect their tents to live in while harvesting. The sounds from their music and games would drift across the Fennel Creek Valley. (Tacoma Public Library, Richards Studio Collection, Series D10193-6.)

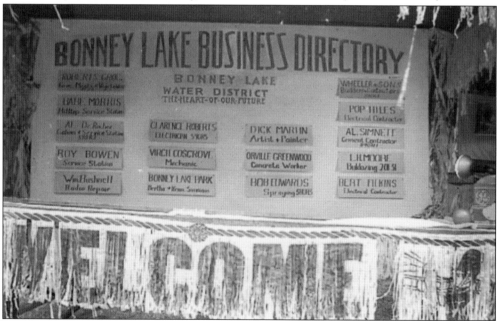

Bonney Lake may not have had a downtown, but it did have a number of people who hoped to fulfill a need for goods and services on the plateau, as seen by this early-1950s business directory. The growing community is reflected by the number of people engaged in contracting services. (City of Bonney Lake.)

Roy Bowen's gas station was a gas pump located at his home on Myers Road. He found a ready market for friends and family in the area and probably catered to the recreational crowd who would frequent Ken Simmons's resort on Bonney Lake. Pictured are Kenneth "Red" Burbank, Polly Morey, and Shirley Bowen. (Bowen family.)

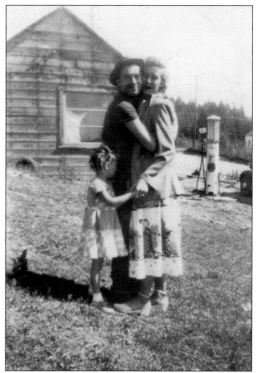

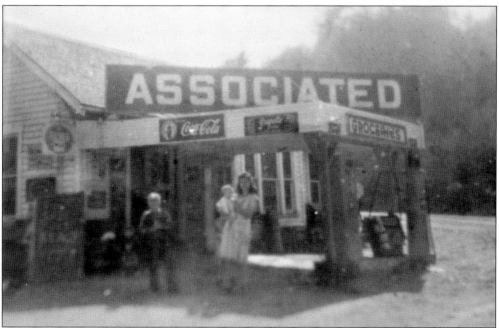

In 1945, Jess Bowen bought two chicken coops from a Japanese farmer in Pacific. He loaded them onto his truck and transported them to the edge of his property at State Route 410 and South Prairie Road, where he ran out of gas. Jess created a small grocery store and gas station, which he sold in 1950 to Milton and Norma More. Pictured are Charlotte Bowen with sons Jerry (in her arms) and Charles (right). (Bowen family.)

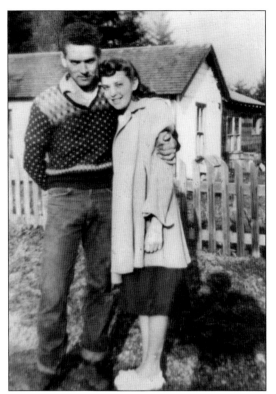

Newlyweds Bob Mayfield and Betty Bowen Mayfield are pictured in front of the home of Betty's brother, Virgil Bowen, on Myers Road, where the young couple spent their early days of marriage. Bob was a truck driver, and Betty later established Mayfield's Florist shop. (Bowen family.)

James Hall built four small cabins with covered parking for each. With people coming to the plateau to enjoy water sports in the lakes or continue on to Mount Rainier National Park, or as a respite for truckers on the busy highway, Hall's cabin camp may have been Bonney Lake's first and only motel. (Barbara Hall Clark.)

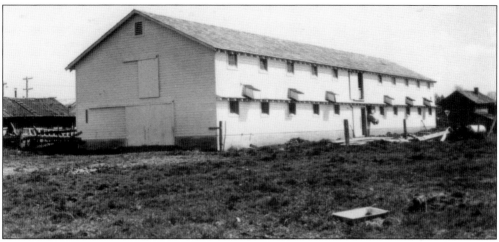

Elmer Hyppa and his wife, Saima, operated the largest egg-producing farm on the plateau in the 1950s. Their two-story chicken house contained approximately 2,000 chickens, but they also leased other farmlands on which to raise chickens. Elmer marketed his eggs at the Sunrise Bakery in Enumclaw and also in Tacoma. (Hyppa family.)

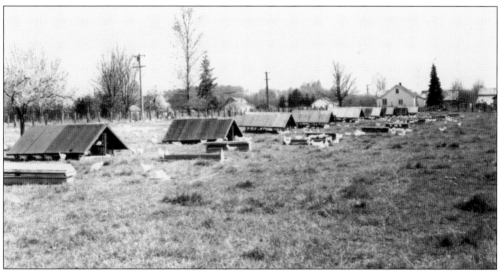

This 1950s photograph of the Elmer Hyppa poultry farm shows the free-range chickens and their tent homes. Since chickens can be adversely influenced by the sight of a wound, resulting in the pecking death of many of the flock, Elmer outfitted his birds with little sunglasses that were mounted to their beaks using a cotter pin through the nostrils, thus calming the flock. (Hyppa family.)

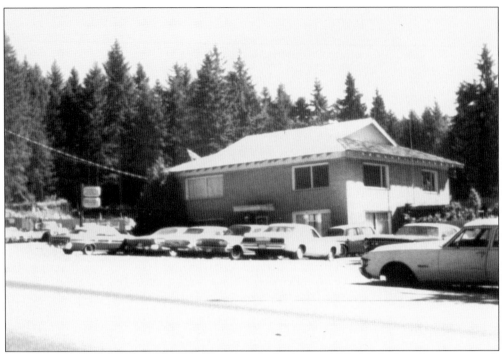

Jess Bowen had planned on building a new car dealership in 1950. He built a showroom with French doors on the ground floor and the family living quarters on the second floor. Poor health changed his plans, and Bowen's Auto Wrecking resulted. In 1998, the business was sold, and Albertson's built a grocery store and shopping complex. (Bowen family.)

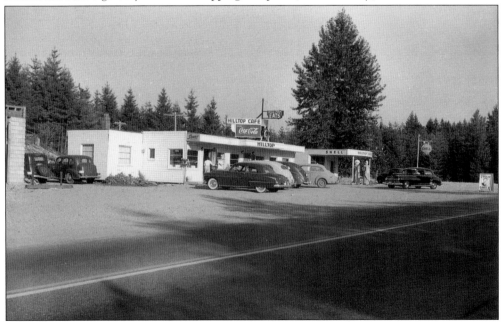

The Hill Top Café, owned by Al DeRocher, opened on July 3, 1948. With only five stools and 168 square feet, it became a popular spot for truckers as well as for plateau families and had grown less than two years later to 1,000 square feet, with seating for 50 people. (City of Bonney Lake.)

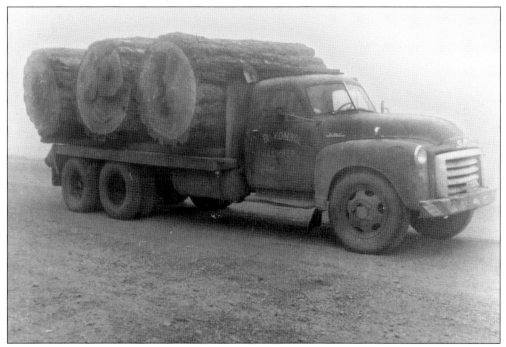

The Hilltop Café was a frequent stop for truck drivers who drove the route between forest and sawmill. There were still remnants of old-growth trees being harvested, some as much as eight feet across. Some of the big trees can be seen in this 1959 photograph of the B. Kombol Lumber truck. (Greater Bonney Lake Historical Society.)

Doug and Jill Cartwright opened the Kelley Creek Brewery in one of the old dairy buildings on the Kelley Farm on December 4, 1993. It was the first microbrewery in Pierce County. Summer concerts, mountain bike races, and an annual haunted house were eagerly anticipated events that brought a sense of community to the plateau. (Jill Cartwright.)

The new Family Market, part of the Tradewell chain, opened its doors on May 26, 1982, at the intersection of State Route 410 and Old Buckley Highway. It was the first of its kind in Bonney Lake, featuring the new scanner method of checking out. The store provided plateau residents with a greater choice of products than ever before. (City of Bonney Lake.)

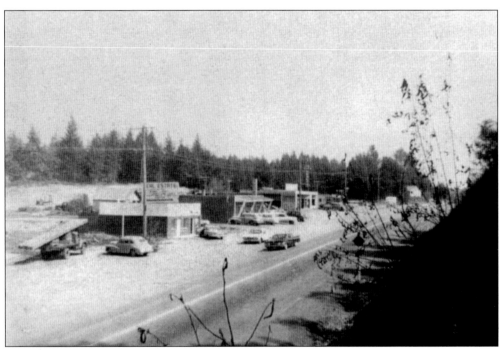

The business district along PSH5 in 1960 is part of today's Bonney Lake downtown triangle on State Route 410. In 1960, there were four realty companies in Bonney Lake, and business was booming. In 24 hours, 136 waterfront lots were sold on Inlet Island; 60 percent of the lots in Ponderosa sold in two weeks, and 500 lots in Cedar View sold within 30 days. (City of Bonney Lake.)

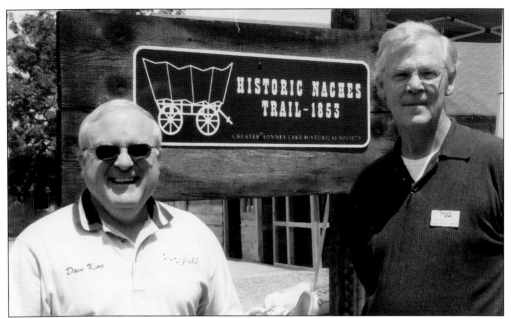

Established in 2001 as a not-for-profit organization, the Greater Bonney Lake Historical Society continues its attempts to establish a museum to display its donated items. Recent accomplishments include the 2007 dedication of the Naches Trail signs at a ceremony at Kelley Farm. Seen in the photograph above, councilmen Dave King (left) and James Rackley provided the funds to assist the historical society in this endeavor. In 2009, joint efforts of the City of Bonney Lake and a funding grant by Pierce County enabled the creation of 10 historic markers around the city, including the one located at Ken Simmons Park on Lake Bonney (below). The Greater Bonney Lake Historical Society was created to promote public awareness, understanding, and appreciation for the history and traditions of Bonney Lake and the plateau. (Both, Winona Jacobsen.)

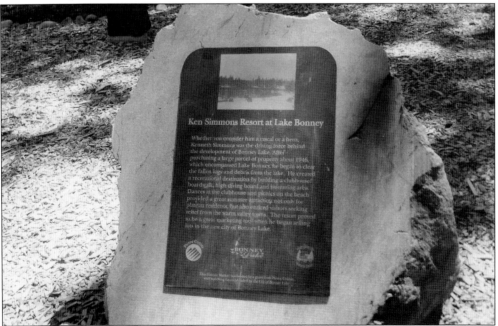

www.arcadiapublishing.com

Discover books about the town where you grew up, the cities where your friends and families live, the town where your parents met, or even that retirement spot you've been dreaming about. Our Web site provides history lovers with exclusive deals, advanced notification about new titles, e-mail alerts of author events, and much more.

MADE IN THE USA

Arcadia Publishing, the leading local history publisher in the United States, is committed to making history accessible and meaningful through publishing books that celebrate and preserve the heritage of America's people and places. Consistent with our mission to preserve history on a local level, this book was printed in South Carolina on American-made paper and manufactured entirely in the United States.

This book carries the accredited Forest Stewardship Council (FSC) label and is printed on 100 percent FSC-certified paper. Products carrying the FSC label are independently certified to assure consumers that they come from forests that are managed to meet the social, economic, and ecological needs of present and future generations.

FSC
Mixed Sources
Product group from well-managed
forests and other controlled sources

Cert no. SW-COC-001530
www.fsc.org
© 1996 Forest Stewardship Council

Find Your Place in History.